DEDICATED TO PABLO

CONTENTS

Fine ART PUBLICITY

The Complete Guide
For Galleries and Artists

Second Edition

Susan Abbott

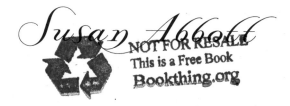

ALLWORTH PRESS
NEW YORK

ART WORLD
PRESS

San Francisco

12 11 10 09 08 7 6 5 4 3

Published by Allworth Press
An imprint of Allworth Communications, Inc.
10 East 23rd Street, New York, NY 10010

Published by Allworth Press and Art World Press, an imprint of Abbott & Company, Inc., 841 Smith Road, Mill Valley, CA 94941

Cover design by Derek Bacchus
Interior design and typography by SR Desktop Services, Ridge, NY

ISBN-10: 1-58115-401-1
ISBN-13: 978-1-58115-401-6

Library of Congress Cataloging-in-Publication Data
Abbott, Susan, 1948–
 Fine art publicity : the complete guide for galleries and artists / Susan Abbott.—2nd ed.
 p. cm.
 Includes bibliographical references and index.
 1. Art publicity—United States—Handbooks, manuals, etc. I. Title.

N8600.A2 2005
659'.02'47—dc22
 2004028830

ACKNOWLEDGMENTS

It amazes me to think how this one book has elicited the kindness of so many people. In particular, I wish to thank all the following, who generously contributed their ideas and their time:

Charles Cowles, Charles Cowles Gallery, New York

Susan Cummins, Susan Cummins Gallery, Mill Valley

Michael Dunev, Michael Dunev Gallery, San Francisco

Mel Frankel, Librarian, John F. Kennedy University's Department of
　　Museum Studies, San Francisco

Candice Jacobson Fuhrman, Author of *Publicity Stunts!*, Chronicle
　　Books, San Francisco

Pam Hamilton, Hamilton Ink, Publicity & Media Relations,
　　Mill Valley

Mary Haus, Managing Editor, *ARTnews*, New York

Douglas Heise, Head of Strategy, North American Operations, BBC
　　Technology, San Francisco

Peter Hempel, Vice President, McCabe, Sloves, Inc., New York

Michael Liener, Michael Liener Public Relations, San Francisco

Gretchen Mehring, Assistant Director, Cincinnati Art Museum,
　　Cincinnati

Tressa R. Miller, First Vice President and Director of Cultural Affairs,
　　Security Pacific Corporation

Eddie Okamoto, Director, International Marketing and Media,
　　Mill Valley

Cheryl Orlick, Public Relations Office, Albright-Knox Art Gallery,
 Buffalo
Sara Palmer, Public Affairs Director, The New Museum of
 Contemporary Art, New York
Michael Phillips, Co-author, *Marketing Without Advertising*,
 Nob Press, Berkeley
Julie Sasse, Administrative Director, Elaine Horwitch Galleries,
 Scottsdale
Pamela Thatcher, Public Relations Association of America, New York
Lulu Torbet, writer and artist
Jody Uttal, Media Consultant
Barbara Webb, Public Relations Consultant

I owe a debt of gratitude to writers in the arts and in the general public
relations field. To Elizabeth Hess, art critic for the *Village Voice*, who
gave me her time and special insights into the world of the art critic—
and to Pam Hamilton, who gave me insight into the workings of pub-
licity from the perspective of an arts and entertainment PR agency.

Many thanks to Polly Winograd Ikonen, director of communica-
tions for the San Francisco Museum of Modern Art (SFMOMA), for
her careful reading of the manuscript and her invaluable perspective in
revising the book to reflect current museum and art publicity practices.

Special thanks to Jo Yanow-Schwartz, editor of *Art Business News*, for
her thoughtful readings, good suggestions, and encouragement at every
phase of the project, and to Kate Kelly for writing *The Publicity Manual*,
a clear, concise publicity guide for small business, which inspired this
specialized one for the art community. She has generously allowed us to
draw on her material.

Special appreciation is also due to Cristina Nichol, Margot Van
Riper, and Dom Martin (Accurateword, Mill Valley) for their research,
word processing, and other numerous contributions. This revision
could not have been possible without the heroic efforts of Amity
Stauffer who provided excellent insight, research, editing, and patient
shepherding of the manuscript through its many metamorphoses. I
would also like to thank Tad Crawford, my publisher at Allworth Press,
for his friendship, patience, and good faith through the many hurdles of
this revision. Finally, heartfelt thanks to my family and friends for their
patience and support throughout this year.

When I was in college studying art history, I worked part-time in a public relations firm. I was fascinated by how simple and effective the tools of the PR professional are and how valuable it is to know how to promote an idea. Later, when I started to consult with galleries on marketing issues, I found that the galleries were using perhaps only 10 percent of the public relations opportunities available to them. My clients didn't seem to understand the direct relationship between the visibility of a gallery and its success. They also undervalued the role publicity plays in keeping old customers and developing new ones.

There are certainly new customers out there to develop. I think the potential audience for art is considerably larger than it is perceived to be. Art is fast becoming a mass-culture phenomenon in America. Certainly one can say that the general public is more interested in art than ever before in our history. As museums become savvier in how to package their programs to reach mainstream audiences, they are reaping the benefits of this nascent interest in art and design. You have probably heard the often-quoted statistic that more people have visited museums in the past decade than in the preceding hundred years. When people attend museum shows, it's the first step to coming to your gallery. Major American museums, using sophisticated mass-marketing techniques, are greatly impacting today's art audiences, and these techniques are beginning to influence gallery promotion strategies and, in some cases, how artists market themselves directly to their core constituencies.

With the expansion of the Internet and art-related portals, there now exists a phenomenal capacity for providing art education and exposure through virtual museums, exhibitions, and gallery or artist studio tours online. Today's collectors initially need not go further than their computer screens to interact with the world of art.

These potential new collectors can be overwhelmed by the choices in the visual art market today. They want to know where to go and whom to trust. Publicity can help them decide that it is your gallery they should visit and that it is you they should trust. One thing I have learned in my years of involvement with art is that the more education people have about what they are seeing, the more interested and committed they become.

We are on the threshold of a new era where people will be able to turn their plasma screen televisions on and bring museums, galleries, and artist studios into their living rooms. Some institutions are worried that it will cut down on attendance, and have been hesitant to embrace this new technology. I think the benefits of exposure to a worldwide audience and the capacity for pre-educating potential audiences far outweighs the fears that new technology may cut down on attendance. To be fully appreciated and experienced, most art still needs to be viewed in person.

I have tried to create a book that will give galleries and artists the tools of the professional fine art publicist and will provide them with some ideas on how to expand the boundaries of their public relations efforts to meet the challenges of this exciting time.

SUSAN ABBOTT

INTRODUCTION: USING THIS BOOK

While this book has been designed mainly for gallery directors and their staff publicists, I think it will be highly useful for artists, who are playing an increasingly active role in marketing their own work. The general text will also be useful for small to midsize museums and nonprofit art galleries that are in some ways closer in scale to retail galleries than they are to large museums.

The nuts and bolts of fine art publicity are the same whether you are a commercial or nonprofit gallery, or an artist. The groups this book is written for are mutually dependant on one another for success, and I believe they will benefit from understanding each other's concerns and perspectives. Furthermore, the boundaries that have traditionally differentiated the role of museum, gallery, or artist have become blurred to some extent by the advent of the Internet, digital technology, and mass-marketing techniques. This trend will only increase as these technologies become more sophisticated and embraced throughout all areas of the artworld.

Today, there seems to be a direct correlation between an artist's involvement in promoting his or her work, and the success of that work in the marketplace. Therefore, each chapter includes special tips, when appropriate, to artists, and artists have a special chapter devoted to their unique public relations concerns and issues.

If you are an artist, this book can give you a practical approach to self-promotion, as well as an understanding of how you can help a

museum or gallery promote your work more effectively. It will also show you how to keep important constituencies, like curators, dealers, critics, and collectors, aware of your work and your activities. Effective publicity starts with the source, and that is the artist. To the extent that you can provide professional PR material that gives appropriate insight into you and your work, you will be maximizing your potential for the success and recognition you deserve.

If you are a gallery director, you can use this book to plan your level of public relations activity, to set objectives, and to develop creative strategies. Your staff publicist or coordinator can then use it as a reference book as he or she implements each strategy.

Setting goals will be the key to your success. Spending time and resources without clear objectives is like getting into your car and speeding off to an unknown destination. You never know when you have arrived, or even if you are going in the right direction. With a carefully mapped-out strategy, you may find you are closer to your destination than you would have believed. I hope you enjoy this book, and I wish you an exciting and successful journey.

1

Publicity is media coverage you don't pay for, and it is the most effective way to introduce yourself and your gallery to the public. Generally, the more familiar people are with your gallery, your logo, your artists, your programs, and you as a personality or community member, the more confidence they will have in you.

A publicist I know likes to use the example of the man with a teenage daughter: Would he prefer to have her go out with some young man he's never seen before or the boy next door? Familiarity can go a long way toward building confidence. And confidence is the key factor in people's art-buying decisions—more important than quality, price, or convenience.

Regional art dealers often complain that people go to New York to buy, even when they're buying works by artists from their own region. This is the quintessential example of confidence winning out. Art in New York seems to have a sort of seal of approval that says, "If it's from New York, it must be good." The reasons are not hard to find. New York galleries are in the art capital of America, they receive more free media coverage, and, because they have a greater volume of business, they can afford to buy a greater share of national and international advertising.

But you don't have to relocate to New York. There are many media opportunities available to you where you are. Regional galleries can get an astonishing amount of coverage in their local communities and worldwide exposure if they have a Web site. The secret is to figure out

the type of exposure that is likely to benefit your gallery most, and go after it.

> **ARTIST TIP:** If you are represented by a gallery and/or your work is exhibited in a museum, you must work cooperatively with the gallery or museum in its publicity efforts. Remember, staff members cannot effectively sell or show your work if they don't understand it, and they won't be motivated to do so unless you develop personal relationships with the staff, from the director to the receptionist. Make everyone your advocate.

> **ARTIST TIP:** Collectors whose visual acuity is not highly developed are greatly influenced by the recommendations of other collectors, gallery directors, or the media's endorsement. You should seek publicity whenever possible to keep your name in the forefront of the minds of people of influence to your career. Press releases are great for distributing to potential patrons, for posting on your Web site, and for supplying these samples to galleries or museums that show your work, or might in the future.

Public Relations Versus Advertising

The term "public relations" (or "PR") describes all those activities you do to generate publicity and goodwill. The overt goals for a PR campaign are similar to the primary goals for advertising—to increase awareness of your name, logo, image, and artists, or to promote a special event. If your finances allow it, you will want to have a good advertising campaign. But PR also plays a more complex and significant role, because it develops your reputation, which in turn develops the public's confidence in you and what you have to offer. Any press coverage you get will carry more weight than ads, since the public sees it as a third-party endorsement. Publicity also can reach people advertising might not.

For example: When a photo highlight of your exhibition appears in the local newspaper's Sunday arts-and-culture section, readers assume that the editor chose to print it because it was worth featuring (when in fact the editor may have just picked the best of the photos submitted).

For example: If you deal in large-scale sculpture, you may want to communicate with real estate developers through their trade magazines, perhaps with a feature article on incorporating site-specific work in hospitals or hotels.

For example: Consider that a benefit art auction might best be announced in the society pages.

For example: If your gallery is part of an important art movement, the movement might be covered in the art trade magazines as well as in special interest magazines, e-zines, and daily periodicals.

For example: If your exhibition has particular appeal to special interest groups, target your publicity efforts toward media that are followed by the relevant groups.

For example: Imagine you are a public relations professional at a gallery publicizing an upcoming exhibition of an African-American artist who is also a jazz musician. In addition to your usual press contacts, you would want to make special overtures to African-American magazines, e-zines, and social and cultural organizations, as well as your local jazz radio station and jazz-related magazines and newsletters.

In all these cases, advertising by itself would be a very expensive, ineffective way to communicate with all of the different audiences you want to reach. Although a publicity campaign can be national or international in scope, it is always the best way for any gallery to reach an audience within a hundred-mile radius. In most cases, this audience represents at least 50 percent of a gallery's revenue.

I mention this percentage because galleries that do a lot of national advertising frequently regard their local publicity efforts as the stepchild of their marketing effort. "We've already spent $30,000 on advertising and it hasn't brought any business in the door. Why should we spend time on local publicity when we're not even guaranteed coverage?" The answer is that not only are local audiences often the bread and butter of gallery revenue, local collectors are usually the ones who support regional artists, the cornerstone of many gallery activities. By building a portfolio of local media coverage you can leverage it to get national coverage or museum recognition for your artists.

PR and Advertising Working Together

A good advertising and PR campaign can make the crucial difference between someone wandering into your gallery cold and suspicious, and someone coming in already eager to see what you have to offer. You will get the best results when both these components of your promotional efforts are developed to support and complement one another.

ARTIST AND GALLERY TIP: Too often artists and galleries spend so much on advertising that they shortchange their PR budget. Artists and galleries tend to splurge when they have a big important show. They may buy a full-page ad in a magazine in which they have not built a presence previously. Generally speaking it is better to have a consistent small presence month after month in the same media outlet than a one-time large splash before a big show. Slow and steady fills the bucket of name recognition in the minds of both the media and your general audience. Some of the extra advertising dollars would be better spent on public relations strategies that will garner free media coverage, such as a frequently updated Web site, reviews, profiles, or interviews.

A gallery might decide on the following campaign to promote both its sculpture inventory and the consulting services it offers to architects and developers:

- Place a small ad twelve times (once a month) in a major regional commercial real estate magazine
- Submit two major feature ideas to the magazine within a year: (1) an article to be written by the gallery director on how to incorporate site-specific work in a project, and (2) a photo essay to be developed about a successful local commissioned project by one of the gallery's artists, including interviews with the artist, happy tenants in the building, and the proud developer
- Create a recurring e-mail newsletter on sculpture and its uses in real estate projects, and send it to local developers, landscape architects, and architects on a bimonthly basis

This campaign is sure to be more effective for the gallery than an isolated feature story or an unsupported advertisement. The idea is to reinforce one marketing strategy with others so that the message is sure to penetrate the audience's ignorance of you and your message. The less familiar you are to an audience, the more strategies are needed to gain their recognition and build confidence.

Recognition and confidence influence people in the media, too. The media's job is to bring the best and most current information to their audience. They are interested in covering the leaders—the healthiest, most representative, and trend-setting galleries. But how do members of the media assess these qualities? One way is by measuring how much

publicity a gallery receives and by its fiscal strength, which is often expressed through large advertising budgets. Thus a large and consistent advertising budget may aid a gallery in positioning itself as a leader.

> **ARTIST TIP:** The media will often judge how "hot" a contemporary artist is by scanning how much accumulative media coverage that artist has received. An upsurge in positive media buzz or word of mouth about you will likely reach the ears of collectors and patrons, and pique their interest in you and your work.

When you are considering magazines and newspapers that have serious critical art reviews with bylines, however, it is crucial to remember that the editorial staff is quite separate from the advertising staff. The editors have the responsibility for developing criteria for coverage and for conducting their own research. Writers and reviewers will reach their own conclusions about the relative quality of an exhibition. Advertising clout has little or nothing to do with what is covered editorially, or how an exhibition is reviewed.

In some cases, a mass circulation magazine will solicit a gallery for advertising when it is featuring the gallery's artist or when an editorial focus, such as an issue on the region's art, includes coverage of the gallery. Two ads placed in advance issues, followed by a smaller ad when the feature appears, will capitalize on the publicity while avoiding the impression that the gallery somehow paid for the feature.

Publicity and Today's Art Audience

In the old days, when the artworld had more purity, collectors seldom even saw the artist. Now collectors want to have some fun, they want to show off art and the artist.
> —John Alexander, quoted in Paul Gardner's article,
> "How to Succeed (By Really Trying)," *ARTnews*

The preface mentions how the audience for art is broadening. Buyers now are less knowledgeable than the art patrons of the fifties and sixties who collected art primarily for its own sake. Today's audience is more likely to buy art for other reasons—as a lifestyle or decor statement, for investment or status, for the values that the piece of art communicates, or because it's trendy.

For the unsophisticated client, this superficial sort of involvement may be the door to making a meaningful connection to the work of art.

Appreciation of its artistic or plastic elements may only come after living with the piece. Publicity is a valuable way to create a bridge between the potential client and the artist or the director of the gallery.

The intimacy created by an interview posted on a Web site or feature article printed in the lifestyle section of the newspaper may be the reason someone will become interested in an artist's work. The same is true for why someone is drawn to a particular gallery or art dealer. Publicity can personalize your relationship with the public and help clients differentiate you from your competition.

It is my belief that the success of a gallery in the next decade will be measured by the director's understanding of the shift in the art audience from the few cognoscenti to a broader-based, less knowledgeable but eager-to-learn audience, an audience that includes those interested in art for art's sake as well as those who view art events as social destinations. The challenge is in reaching these people, meeting their needs, and inspiring their loyalty. This creates a new role for artworld professionals as educators or expert resources for interested, evolving collectors as well as artworld novices.

One way to reach them is through their hunger for social interaction. Museums have very successfully led the way by turning their institutions into social destinations and their programs into excuses for the gathering of like-minded individuals. Fancy, in-museum food emporiums, singles night events, musical and theatrical performances, and lectures of all kinds, held right in the museum, are drawing increasingly diverse audiences.

Galleries have caught on to the trend by hosting crossover events such as poetry slams or wine tastings, or by cooperatively scheduling openings on the same night and encouraging gallery hopping—in the tradition of the pub-crawl. Artists have jumped on the bandwagon by hosting open studios, private collector parties, or special events, such as cultural tours to other cities or even other countries for cultural discussion groups or painting instruction.

Choosing a Publicist for Your Gallery

The best way to make sure that your publicity is effective and consistent is to have one person responsible for all of your dealings with the media. Often a gallery director is simply too busy to stay on top of all the details involved in a good publicity campaign. In-house publicists have the opportunity to be involved in the planning of events and exhibitions from their inception and have the opportunity to anticipate public reaction and prepare a response. But whether you choose to hire an in-house publicist or an outside contractor, you should choose your publicist

carefully. This person will become the voice of your gallery to many of the people who mean the most to your success.

Choose an outside publicist who specializes in arts publicity; you will need a publicist with established artworld connections. Your publicist should also have strong editorial skills in order to write your press releases—the critical link to the press. It is also crucial that your publicist be friendly, knowledgeable, and outgoing. At first, dealing with the press may seem overwhelming and impersonal, but soon all the key media people in your area will become familiar on a personal basis.

By always being the gallery's press contact, by submitting accurate and timely material, and by following up any requests for information promptly, your publicist will build up a relationship of personal trust. Gradually, the local media will come to see your gallery as an ally in the fight against the deadline, a trusted resource on which they can rely.

Tackling Your Own PR (for Small Operations or Individual Artists)

As more artists decide to represent themselves or take a more proactive role in the marketing of their work, every artworld professional should learn at least the basics of PR. With this book you *can* do it yourself— any good writer, say someone with a journalism or liberal arts degree, can do the PR for an individual artist or small gallery or museum. For emerging artists and small galleries or museums, the money for promotion is likely to be scarce. Focusing your initial efforts on attracting "free" publicity through the media is the most cost-effective use of a modest budget.

Just remember that building public recognition of and interest in your "brand" takes time when you are starting from scratch. And don't go completely solo—even the best writer needs someone else to proofread his or her writing. Few things turn off a media contact more quickly than a typo-ridden or poorly constructed press release.

2

YOUR MARKETING PLAN

A marketing plan lays out what you want to achieve, and a public relations plan helps you get there. It follows that the clearer your marketing plan, the more targeted and effective your PR can be.

Every marketing plan will be different. Although two galleries in the same city may be showing similar work, their goals may differ radically, and so their strategies will differ as well. Every publicist can profit from Puss Cat's advice to Alice in Wonderland:

"Which way should I go, Puss Cat?"

"It depends on where you want to arrive."

Basic to your planning is precise knowledge of what your gallery has to offer and who will be interested. In business, this is known as a "mission statement," the foundation of your marketing plan. If you can establish an ongoing process of evaluating your art and your services, as well as your target audience, you will be able to keep your gallery, its exhibitions, and its publicity on track. This is your road map to success.

In most cases, because the artworld today is such a competitive market, it makes sense to concentrate your marketing efforts on only a few different audiences. Otherwise, you run the risk of trying to be all things to all people and being nothing of note to anyone.

For example: A gallery that supports itself by selling expensive secondary material to serious collectors but also exhibits works by emerging artists will have difficulty communicating an image, because

its two main targeted audiences are at opposite ends of the spectrum. Usually in this case a gallery will decide to publicize their emerging artists' exhibitions and depend on word-of-mouth and personal marketing for their backroom sales.

Keeping Up with the Castellis

It rarely pays to adopt someone else's marketing strategies. A common mistake that gallery directors make is to pattern their marketing efforts on their art-dealing heroes, the Castelli Gallery in the sixties, say, or Gallerie Maeght in the eighties. This can be disastrous. These big galleries may be addressing an audience entirely different from yours. Your potential clients may have a regional interest or may want to support emerging artists. They may be neither as sophisticated nor as ruled by trends as those in New York. A campaign that would wow New Yorkers may not be even vaguely appropriate for your gallery.

Describing Your Gallery

On the next page is a worksheet for describing your gallery. Filled out, it should give a clear picture of what the gallery is all about. Whatever represents 80 percent of the gallery's collection should be the dominant image to promote through your marketing efforts, and each piece of publicity should reinforce that image. This ability to project a single image is the most powerful marketing tool a small business has. As a gallery, you can be flexible, make quick decisions, and focus your activities so they all work together.

By the way, once the description has been used for this kind of analysis, it can be tossed away, but you might want to keep it in a drawer to ward off the temptation of exhibition offers that seem compelling but are not relevant to your gallery. It is also good to have on hand to show to a staff member who is gung ho for an inappropriate exhibition idea.

Description of the Gallery

CENTURIES:

❏ 18th ❏ 19th ❏ 20th ❏ 21st

REGIONS:

❏ American ❏ European ❏ South American ❏ African
❏ Asian ❏ Australian ❏ Other

MEDIA:

❏ Sculpture ❏ Paintings ❏ Drawings ❏ Graphics
❏ Ceramics ❏ Textiles ❏ Photography ❏ Video
❏ Sound ❏ Digital ❏ Multimedia

SPECIALTIES:

TYPE OF ARTISTS:

❏ Emerging ❏ Mid-Career ❏ Established

ARTISTS WE EXHIBIT:

ARTISTS WE REPRESENT:

ART WE HAVE IN INVENTORY:

PLANNED EXHIBITIONS FOR CURRENT YEAR:

Selecting Your Marketing Goals

Once you have a clear idea of the image you want to project, the next step is to identify your main target audiences and set specific marketing goals for each of them.

Most galleries have more than one marketing goal. While attracting loyal collectors may seem quite naturally to be your primary focus, it may be just as important to attract established or talented emerging artists to your gallery or to develop a national reputation with other galleries so that you can collaborate on exhibitions.

You may also want to strengthen your contacts with centers of influence—those people who by their status in the community can influence the success of your gallery—or with other art professionals, such as curators, critics, or museum directors.

Selecting Your Strategies

For each goal you identify, you can develop strategies drawn from the following categories:

PROGRAM DEVELOPMENT
Gallery Exhibitions
Loans and Commissions
Special Events/Activities

ADVERTISING
Local Newspapers, Classified Advertising
National Art Publications
Trade Publications
Other Professional Publications
International Art Publications

CALENDAR LISTINGS
Free Listings
Paid Listings

DIRECT MAIL AND E-MAIL
Promotional Piece (e.g., a catalog)
Museum Mailing
Special Interest Mailing
Trade Mailing

IMAGE DEVELOPMENT
Physical Appearance of the Gallery

Client Service
Graphic Design for Stationery, Logo, Ads, Etc.

WEB SITE CONTENT
Digital Archives of Works for Sale
Links to Artist's Sites and Other Galleries
Gallery or Exhibit Tour Online
Catalog Reprints
Press Reviews of Past and Current Exhibitions
Gallery Staff Photographs
Archive of Artist Represented
Collector Education Content
- Photos of their works
- Artist biography
- Artist statement
- Press reviews

Gallery Mission Statement or Collection Philosophy
Directions to Gallery

PUBLIC RELATIONS
Articles You Write or Have Written
Newsletters
Special Events
Power Dinners
Lectures/Demonstrations by Artists
Studio Visits
Lectures by Art Professionals
Special-Invitation Previews
Press Conferences
Cultural/Community Events
Cooperative Ventures
Contests/Awards
Auctions

NETWORKING AND PERSONAL MARKETING
Social Events
Trade Events
Personal Contacts with Clients
Contacts with Centers of Influence
Organizations You Join
Relations with Artists
Relations with Others in the Trade

Gallery Marketing Goal and Strategies

A gallery located in Santa Fe, New Mexico, identified two of its target audiences (70 percent of its sales) as tourists and part-time vacation residents.

STATEMENT OF GOAL:

The purpose of our marketing effort to tourists and seasonal residents will be to:

1. Develop greater name recognition for the gallery and its artists
2. Extend the tourist selling season
 - Let them know we're a year-round resource
 - Create events to help extend the season
3. Promote Santa Fe as an art destination

SELECTED STRATEGIES:

Advertising:
- In-flight magazines of Southwest Airlines, etc.
- *Santa Fe* magazine
- Tourist "What's Happening" publications
- Web links to regional art and tourism Web sites

Public Relations:
- Expand our mailing list by trading with a Texas-based gallery; e-mail and send special announcement invitations for one year and then send mailing list update
- Seek a feature article on the gallery or our artists in all in-flight magazines on airlines that fly into Albuquerque as well as in Santa Fe publications
- Seek a tourist cable network interview for (artist) at his or her studio
- Sponsor a cocktail party for opening night of the Opera
- Plan an exhibition at the Performing Arts Center
- Loan an exhibition to the (hotel)
- Develop an e-mail newsletter to stay in touch with out-of-town clients

Image:
- Have our banner redesigned so people can see it from the Square
- Develop a gallery information packet for new clients; do overrun of (artist's) catalog to use as packet cover

ARTIST TIP: As an artist, it also helps to define who you are professionally and what you do in order to publicize and market yourself properly. Sometimes artists work in several very different arenas and need to make a strategic decision about which body of work to market. In other cases the work is complementary and can be marketed together.

ARTIST TIP: After you have identified the body of work you want to promote and your goals for the coming year, you can either work with your gallery or on your own to develop strategies that will help you achieve your goals.

Description of the Artist

MEDIA I WORK IN:

❏ Sculpture ❏ Paintings ❏ Drawings ❏ Graphics

❏ Ceramics ❏ Textiles ❏ Photography ❏ Video

❏ Sound ❏ Digital ❏ Multimedia ❏ Mixed Media

SHORT DESCRIPTION OF MY WORK
(What distinguishes my work from others):

MAJOR ARTISTIC INFLUENCES (PAST/PRESENT):

REPRESENTED BY GALLERIES:

ACQUIRED BY MUSEUMS:

ACQUIRED BY COMPANIES OR PUBLIC SECTOR ORGANIZATIONS:

ACQUIRED BY MAJOR COLLECTORS:

ART I HAVE AVAILABLE FOR SALE:

CURRENT COMMISSIONS:

PLANNED EXHIBITIONS FOR CURRENT YEAR (DATE/VENUE):

CAREER GOALS FOR THE NEXT SIX MONTHS:

CAREER GOALS FOR THE COMING YEAR:

MARKETING GOALS FOR THIS COMING YEAR:

Communicating within Your Organization

Many museums are now having their staff work in project teams, with individuals from various specialties (curatorial, education, registration, installation, marketing) working on the development of an exhibition from the beginning. PR should have a representative on each project team. For large galleries, you should give PR input in planning exhibitions if you can. PR can be particularly helpful in deciding the timing of exhibitions in relation to other major cultural events, other museum openings, holidays and seasonal attendance trends, and other conflicts. For example, as attendance is traditionally low right before Christmas, it would be a bad time for a big opening.

As with any larger organization, larger galleries must have good internal communication in order to project a clear and cohesive message to the outside world. The entire staff is a representative of your organization so make sure they act professionally at all times while on the job. Any contact with the press and the public has an impact on how you are perceived. Everyone on your staff should know your PR message and be able to articulate it. However, the staff must be instructed not to speak to the press without going through PR first. This ensures that PR is fully aware of every message that is being sent.

Measuring Your Success

Once you have mounted a PR campaign, how can you measure its success? There are two basic ways: surveys of opinion and documentation of activities.

The first is simply the process of surveying your audience or using evaluation forms and reviewing them. After all important campaigns, ask members of your staff to note their personal observations and the comments they received. Make a list of your own impressions about what went wrong and what went right. You should be able to get a fair idea of how you are doing from reviewing these subjective impressions.

The second, documentation of activities, is the list of all your PR efforts and any identifiable results, e.g., the number of press releases sent; attendance of media at the event; public turnout; the number of reviews, listings and photo highlights garnered for the exhibition; and of course, sales and increased interest in the gallery or a particular artist.

If your results seem substantial and impressive, you can celebrate, but they should still be checked against your marketing goals. Let's say your goal was to sell 70 percent of an exhibition during the six weeks it was up in the gallery and to achieve national media attention for its

artist. If you sold 80 percent of the exhibition and received three excellent reviews in regional publications but none in national art magazines, you achieved only 50 percent of your goal. You now may want to take those three great reviews and send them with a follow-up note and press release to the national magazines, suggesting that they consider this artist for a feature article. Or you might save them to include in the national press package for your next show of this artist.

So the rule is that activity alone is not a measure of success; the activity has to help you achieve your goals.

3

PUBLIC RELATIONS PRIMER

The task for any gallery publicist today is not just to get the word out, but to make sure it lights up the sky. Your audience must not only see your message, but must be dazzled by it. This can be a formidable challenge.

Consider this story from a successful Baltimore publicist: The first day on the job, her boss took her to lunch and then stopped in at the offices of the *Baltimore News* across the street. He said, "See the man at the desk over there, buried under an avalanche of papers? How are you going to make your releases stand out in a pile like that?" In today's digital world where most press releases are sent out over e-mail, the challenge to differentiate yourself online is even greater.

This book will help you get the best coverage possible for any single event, but before I get into details, there are two other points to consider: publicity has a cumulative effect, so patience in sustaining a long-term publicity strategy is a key element to success; and the effort put into a publicity campaign must be adequate to get the job done.

In the long run, publicity will be only as good as the exhibition or event you are publicizing—it does no good to have a first-rate campaign and then have people disappointed when they turn up at your gallery. But it is just as self-defeating to put all your energy into an exhibition or special event and then not publicize it sufficiently.

A lesson may be learned from two California oil companies that I'll call X and Y. Company X was a major supporter of cultural programs, but 90 percent of its contribution dollars went into the programs and

only a small amount into public relations support. Company Y, on the other hand, was a significantly smaller contributor to the arts, but its policy was to match its program funding with an equal promotions budget. Surveys showed that Company Y had a much higher recognition rating than Company X. Company Y got more accolades for its charitable donations because more people knew about them.

In the business world, a public relations event is often conceived just for the purpose of getting media attention. Too often in the artworld the publicity opportunities of an event—an artist's lecture, a contest, an auction—are ignored or at least are not developed for their maximum effect.

Galleries often put on interesting educational events, but announce them only to a select group of clients. "We're going to keep this quiet. If we let the public know about it, art gallery groupies might show up."

Two points:

1. The more people who show up for an event, the more energy and excitement are generated and the more confidence is built in the minds of the participants
2. Many people will not attend, but when they read about the event, valuable exposure will be created for your gallery

See "Grabbing the Spotlight" on page 29 for some ways that galleries have aggressively gone after publicity.

Blowing Your Own Horn

Gone are the days when a gallery director could keep a low profile and let the art speak for itself. The new collectors are more likely to rely on the knowledge of gallery directors, and they want to know the people they are dealing with. Whether you are a legendary New York dealer like Leo Castelli, Mary Boone, Paula Cooper, or Ivan Karp, or a regional art dealer doing a great job, you not only have an educational role to play, you also have your own personal image to cultivate. This may be the single most difficult mental switch for today's gallery directors. Instead of being able to immerse yourself in matters of art, you must think about your image in the community.

Bringing attention to your own activities helps to establish that your business is built on excellence and trustworthiness. You do this by being visible—by attending events in the artworld and in the community, by writing articles or by having articles written about you, by giving lectures or appearing on talk shows, by taking an active part in community organizations and by setting up contacts with clients and influential community members. In these ways, you give evidence of your com-

mitment to the community and you show that you are an authority in your field.

The first step is to take inventory of your personal image and set some long- and short-term goals. No one is good at everything, so choose ways that you can parlay your strengths into goodwill and publicity. Whenever you have a chance to publicize your activities, be sure to send out a release letting people know what you are doing. The results are nearly the same whether someone comes to an event in which you are involved—such as being an art auctioneer at the PBS fundraiser—or whether they simply read about it in the paper.

In chapter 9, I discuss a background release, which is the basic publicity tool for anyone seeking personal visibility.

> **ARTIST TIP:** Whenever you change gallery affiliation, sell an important work, receive a grant or major commission, it is an opportunity to communicate with the media. Don't wait until your big show to get out press releases to appropriate media. Build your reputation and your relationship with the press over time by keeping them abreast of significant milestones in your career. But beware—sending releases to inappropriate media can backfire. While an art trade magazine might publish an announcement of a major commission or grant, the art critic in the local daily news probably would not. Repeated inappropriate press releases will damage your credibility.

Writing Articles

One way to enhance your reputation is by writing mini-features or short informational articles. (If you don't like to write but have a lot to say, consider hiring a ghostwriter to work with you.) If you get several such articles printed a year, members of the press will eventually see you as a valuable resource.

Here are some ideas for articles for local newspapers:

- Art as an investment after a heavy stock-market decline
- The hottest new form of leasing art and who should consider it (for the business section)
- What is happening in the art market from the collector's point of view
- How to recognize quality in an emerging artist's work
- How to sell works you've outgrown
- Advice on selling art on online auction sites

This kind of article must not be self-serving, and the subject matter must be treated objectively. Although doing research, developing the theme, and substantiating the facts will take some time, the gallery's image will be enhanced by the exposure.

ARTIST TIP: Artists who teach or like to write have been very successful at building their brand with collectors, museum professionals, and art critics by writing opinion essays, features, or educational articles. Some examples of topics artists have written are:

- The value of elementary school art education
- New techniques in print making
- How digital cameras have revolutionized realistic painting
- Reviews of local exhibitions at galleries and museums
- State and local museum funding
- Defining obscenity in art

Sample Letter Proposing
a Feature Article

This is a generic letter used by Public Relations Consultant Michael Liener in promoting his client, Michael Dunev. It's perfectly acceptable for a gallery director to send a similar pitch letter directly.

MICHAEL LIENER PUBLIC RELATIONS

Dear Editor: (personalize with name)

(Add personal paragraph talking about editor and magazine.)

With more and more attention being paid to contemporary art, it is no wonder that the art market has become a serious arena for business investment. Understanding the various options before an investor enters the art market is crucial.

Michael Dunev, the director of the Michael Dunev Gallery in San Francisco, is an articulate spokesperson who has a broad understanding of the historical and aesthetic developments that inform the contemporary art market. Article topics concerning new investor trends in the contemporary art market, business investments in art, the impact of the Internet on the pricing of contemporary art, and the varied directions in recent art movements are article subjects that can be tailored for your publication.

Enclosed please find background information on Michael Dunev as well as some recent articles on the contemporary art scene. Likewise, I am including a profile of the San Francisco gallery, its aesthetic vision and direction of growth, and the international group of artists who are now being shown. This, too, would make for an interesting profile story.

A five-by-seven, black-and-white glossy of Michael Dunev is available for your use, and digital photo files or color transparencies of the artist's works can be provided to enhance an article or to supplement a feature on Michael Dunev and his gallery.

If you have any questions or need further information, please do not hesitate to call. I look forward to talking with you soon so that we can discuss article possibilities on investing in contemporary art for upcoming issues.

Michael Liener

50 CALIFORNIA STREET, SUITE 3300 • SAN FRANCISCO, CALIFORNIA 94111
TELEPHONE: (415) 673-2218 • FAX: (415) 989-1204
E-MAIL: DUNEVGALLERY@EARTHLINK.COM

Here is the article that appeared in the *San Francisco Business Times,* written by Michael Dunev, director of the Michael Dunev Gallery in San Francisco, and reprinted with permission of the author and the *San Francisco Business Times.*

Recent Advances in Art Prices Raise Questions About Solidity of Investment

BY MICHAEL DUNEV

With present prices for art soaring into the millions of dollars, it's no wonder that more and more attention is being director toward serious investment in contemporary art. Observers of today's art market must wonder if all the excitement and the accompanying exaggeration are fueling over heated prices, or whether the burgeoning contemporary art market represents a true area of financial opportunity.

Over the past three decades, the art market has methodically transformed itself from a discreet and conservative—if somewhat chaotic—subculture into a highly organized and sophisticated financial arena. This transformation has come from the increasing public demand for art as well as some factors which have converged to make the contemporary art market a more attractive and efficient investment vehicle than it was in the past.

News about the art world and specific art markets is ubiquitous. Every corner newsstand has shelves of various specialized art publications dedicated to reporting on and explaining the implications of the latest art world trend.

Museums and gallery directors devote considerable time and effort educating the public. The San Francisco Art Dealers' Association for instance, holds regular seminars on contemporary art issues and a wide range of services focusing on the curatorial direction and support.

Indeed, information on the art scene is hard to escape—from statistical investment analysis of the contemporary market (according to *The Los Angeles Times,* art topped the 1988 investor scorecard as offering investors a 41.99 percent return,

better than rare coins, mutual funds and blue chips stocks) to the wide-eyed media blitz around record-setting prices (a Jasper Johns painting, which recently sold for $17.1 million, set a record for a price paid for a work by a living artist).

Today it is possible to borrow funds to finance art purchases, even to use purchased art works as a source of leverage to make other investments. Many financing options allow an investor to enjoy the pleasure and prestige of hanging art on the wall without tying up the capital. Here are three:

1. LEASING ARRANGEMENTS. Recently, leasing companies have made aggressive moves to enter the art market by offering attractive arrangements to prospective art buyers. Typically a leasing company holds title to the art work over a certain period of time permitting an investor to. deduct payments as a business expense.

While conventional financing usually requires a 20 percent down payment and entitle the buyer to deduct only the interest, under the terms of an art lease arrangement the entire monthly payout—including sales tax, interest and principal—is deductible.

As a result, the art investor pays for the art out of current untaxed income. The ability to schedule lease payments to coincide with income fluctuation further frees an investor's bank line to meet short-term capital requirements. At the termination of the lease, an investor has the option of purchasing a now more valuable work of art

(art does not tend to depreciate in value) at 10 percent of the original purchase price. In essence, the investor rents the art while participating in value appreciation.

2. CORPORATE PENSION FUNDS.

An option being considered by corporate investors is to purchase art with corporate pension funds. For example, Chase Manhattan Bank has announced a $300 million art investment fund that will raise money from corporate pension plans.

The Art Investment Fund will attract minimum investment of $10 million from up to 30 major pension funds with more than $1 billion in assets, making each contribution a 1 percent risk. The art will be purchased with pre-tax money and be considered a non-taxable asset that will increase the overall value of the fund.

3. AUCTION HOUSE AGREEMENTS.

In recent years, Sotheby's and Christie's have taken a bold marketing stance by providing a range of financial services for their clients Consignors can arrange to borrow against their consignment and receive a percentage of the estimated value of their art in advance of the actual sale. This frees up the consignor's capital prior to a sale.

The auction houses also can lend money to qualified investors who wish to bid on certain lots. Although the title for the art remain with the auction house until paid for, this arrangement allows investors to acquire works of art without tying up capital or utilizing alternative financing sources.

Prior to considering any of the above, I recommend that the prospective investor consult with a tax advisor knowledgeable about the particular tax consequences associated with these options.

The increasing diversity in options, coupled with the shift in the art world from a provincial to a global market utilizing the latest in electronic communications and a worldwide network of venues, has created a highly charged and volatile market which is not without its inherent risks.

Art does not have the liquidity of cash reserves, yet the growth of organized marketplaces to link sellers with buyers has considerably reduced the time it takes to sell art. Today, sellers seeking deacquisition have more avenues to pursue, and depending on current trends and prices, turn-around time in a hot market can be only a matter of months. At times when the economy is sluggish, the art market, like all other markets, will suffer from periods of illiquidity.

In recent years extraordinary profits have been reaped as sellers have entered the marketplace with artworks that have greatly appreciated in value. There is no crystal ball which can accurately predict the fickle swings of the art market, and therefore art acquired for investment reasons alone can sometimes be a bitter disappointment.

Due to the vagaries of the contemporary art market, I often discourage the purchase of art for investment purposes only. However, if the investor understands the marker's fickleness, views contemporary art as more than a financial instrument with quick profit potential and understands that a well-conceived art collection represents more than a savvy addition to a portfolio, contemporary art can be a wise investment.

Ultimately, if you cannot accurately predict the course of the art market, enjoy owning the art. Successful art investment must be rooted in the belief that art itself has an intrinsic value, which over time will increase both in social importance and worth.

The contemporary art investor must be motivated by more than personal financial gain. Art investment must be seen in terms of benefiting a wider community. It is the art patron who invites society to examine and take the important steps in understanding the nuances of our time; it is the art patron who provides the necessary platform for a social dialogue between the art and its public and it is the art patron who offers us a valuable legacy for the future.

Michael Dunev is the director of the Michael Dunev Gallery, San Francisco.

Cooperative Ventures with Other Galleries

One way to expand your impact in the art community is to work with other galleries on mutually beneficial projects. When two or more galleries sponsor related exhibitions or activities, they create a media event. From a media perspective, ten galleries deciding to stay open Thursday nights is more significant than one gallery staying open. Two galleries having portrait shows at the same time creates a dynamic situation for an art critic—a chance to juxtapose the reviews—and it increases the odds that the critic will visit and review both exhibitions.

When there are more players in the event, there are also more opportunities to share advertising. Opening nights can be combined to create audience crossover. You can even produce a joint catalog. Generally speaking, these occasional cooperative ventures can be invigorating to an art community and synergistic in terms of publicity.

For example: The members of the art dealers' association in Scottsdale, Arizona, wanted to create an event to cap off their selling season, one that would help establish Scottsdale as one of the art capitals of the Southwest. They petitioned their chamber of commerce to conduct a survey on the impact of art on tourism and to help stage a major four-day event billed as the "Best of Scottsdale." This included:

- Each gallery unveiling its major show of the year
- Each gallery exhibiting sculpture at the performing arts center and plaza
- Sending two direct mail pieces to more than one hundred thousand people (each gallery sent out the mailings to its own list)
- Launching a national advertising and publicity campaign timed to receive national and regional pre-publicity
- Holding a contest to select the best pieces from each gallery and then the best piece of the whole event (contests create media and public excitement)

There was also an artwalk, combined openings, a black-tie gala, and a Southwest brunch. The benefits far exceeded the association's expectations. The promotion eventually became an annual event. The publicity snowballed. Local coverage was excellent, and out-of-state newspapers, including the *New York Times* and regional magazines, covered the event. Local attendance was higher than usual. The whole activity developed cooperation among the galleries, which are diverse in their range

of inventory and their goals. It also spurred a healthy sense of competition. Finally, the success of the event encouraged other galleries to join the association.

Other cooperative gallery events include:

- Ongoing weeknight late gallery hours, when all the galleries agree to stay open the same night, such as Thursday, or to have their openings on the same night; over time, this will make an evening visit to the gallery district an appealing social option
- Artwalks
- Studio tours
- Museum tours combined with gallery tours
- Joint shows on a particular theme (e.g., Santa Fe's "Indian Market Week")
- Sharing art fair booths
- Sharing gallery space in another city (e.g., four San Francisco galleries decide to open a gallery in New York, with each showing a few of its best artists)
- Auctions/benefits (including artist-involved events such as boxcar derbies, artist-designed jewelry or pet accessories, artist and celebrity tie-painting, contests)
- Destination marketing (galleries hire a PR firm to run a campaign in nearby cities to attract tourists to their art community; this can also be done with nonprofit performing and visual arts organizations)
- Cooperative live chats over the Web allowing the public to ask questions of gallery artists or directors
- Lobbying (art dealers' associations, in combination with local museums, have successfully lobbied local newspapers for additional arts coverage—e.g., a new visual arts calendar in the Sunday section and special museums coverage so that there is one critic for galleries and another for museums)

Note: Sometimes an event or program is instantly successful and sometimes it takes several years for it to gain the public's and the media's attention. Don't give up just because it hasn't been an overnight success.

Cooperative Ventures with Non-Art Partners

Not only galleries make good partners for publicity. Other businesses in the community may offer opportunities to get more coverage and reach new audiences.

For example: Arrange a chamber music concert at your gallery and get a local radio station to broadcast it.

For example: Mount a display of antique posters in a local wine shop.

For example: Arrange a rotating exhibition program with a leading hotel restaurant if your gallery caters to tourists, or a rotating exhibit at the performing arts center.

For example: A gallery with an artist who specializes in animals as a painting theme might collaborate with the local zoo or with a conservation group. The artist could design a poster, and the exhibition opening might be combined with a benefit cocktail party at the gallery.

Community Involvement

If you have a special interest or cause you feel deeply about, there may be a way to get involved personally or for the gallery to participate as a sponsor. These opportunities, such as board work, can bring you in contact with people you might never reach otherwise.

A gallery director in Southern California, troubled about drug addiction among the young, created a fundraiser with the local association of concerned pediatricians and family practitioners. Another gallery threw its resources into raising money for the homeless population in the community, while another rallied to save a historic building from the demolition ball.

Fashioning a News Hook

Another way of getting more exposure is to tie an event or exhibition to something already of interest to the mass media. In the trade, this process is called "creating a news hook." On page 49, there is a thorough discussion of how to develop news hooks to get feature articles and news items published.

For example: The Kukurin Company, a marketing and public relations firm for the Makk Gallery in Beverly Hills, played up the artist/art dealer's flight from Hungary as a young man. This tied into the media's then interest in the anti-Communist movement in Hungary. Although Mr. Makk also left Hungary to pursue an art scholarship he had won in Rome, the PR professional chose to emphasize the artist's political reasons for fleeing Hungary.

Grabbing the Spotlight

Publicity stunts and staged events are viewed as unsavory in some circles, but behind many an artworld success is some accidental or bizarre event that created a great deal of publicity. And sometimes the event may even have been manufactured to create publicity, as Candice Jacobson Fuhrman shows in her entertaining book, *Publicity Stunt! Great Staged Events That Made the News* (Chronicle Books). Stunts can include:

- Picking an unusual location to kick off an event
- Creating a photo opportunity (editors are always looking for eye-catching photos or situations where they are likely to capture a good shot)
- Arranging the appearance of a celebrated exotic character
- Staging some preposterous act, like dressing the bar attendants in gorilla costumes
- Setting up an oddball tie-in, like opening an Ed Ruscha lithograph series of Chevron gas stations at an actual station

Often, fortunate juxtapositions are accidental, and it just remains for you to make the most of them.

Sometimes artists can do masterful jobs of self-promotion. It is not unusual for an artist to be acutely aware of his public image and to feed whatever useful myth is currently making the rounds. Here's an excerpt from Paul Gardner's article, entitled "How to Succeed (By Really Trying)," which appeared in *ARTnews*:

> In the early 1970s, when the trumpeted movement was Conceptualism, an upcoming artist named Terry Fugate-Wilcox turned his idea of Conceptualism into a now-legendary stunt that sent up the artworld and lifted him from the mire of anonymity with both television and press coverage. "Things had become so ridiculous that I knew I had to do something to expose the political structure of the art scene," he explains.

> A few years after arriving in New York from Kalamazoo, Michigan, with his wife, he "created" the nonexistent Jean Freeman Gallery at 26 West 57th Street. In fact, there is no 26. The numbers skip from 24 to 28. The gallery's fictitious director was a man named Niesus Stacion. Next, Fugate-Wilcox opened a checking account in the gallery's name, asked the post office to forward Freeman mail to his downtown loft (which also took Freeman phone calls), sent out publicity fliers and, most important, placed ads for the Freeman "season" in art magazines.

The gallery soon was besieged with job résumés, slides from artists, and requests for catalogs and photographs of work by the Freeman stable. Its fabulated Conceptual group included Michael O'Day, known for a 1,000-mile-long gelatinous sculpture executed in the Pacific Ocean, and Gary Palestine, who did sociopolitical land excavations. Under his own name, the Freeman creator published a critique of the Freeman artists in *Arts* magazine. They even got mentions in the Art Index.

Perhaps the master publicist was Andy Warhol, who was fascinated by the awesome power of the mass media and skillfully built the mystique of his personality. His name became a household word, and he became a cult figure bridging the art and entertainment worlds. His whole career might be characterized as a movable feast of publicity stunts. He raised profound philosophical questions about the nature and function of art; at the same time, he pleased the crowd.

Is There a Blockbuster in Your Future?

Attitudes about what types of publicity strategies are appropriate for galleries seem to be changing. The economic reality of today's artworld and the explosion of interest in the arts are putting pressure on the serious gallery to adopt mainstream public relations techniques.

As museums have lost governmental and private funding, they have begun to go after mass audiences, the same audiences commercial galleries have long considered their exclusive constituency. Museums have built blockbuster shows with blockbuster PR for several decades now, complete with billboards, radio and TV spots, Web campaigns, posters in public places, tie-in promotional products, and related special events.

Successful commercial galleries have also upped the ante, with elaborate campaigns using these same marketing strategies.

For example: When she was planning an important exhibition, one Texas gallery director decided to go for a high-visibility marketing campaign consisting of an illuminated billboard on a major interstate highway, a full-page ad in a major magazine, thousands of direct mail invitations, a series of radio ads, and a fifteen-by-thirty-foot banner over the gallery. A special phone line was also set up to handle the calls generated by the billboard and the radio spots. The local radio station agreed to broadcast live at the reception for the artist and aired another eighteen commercials, at no cost, to publicize its participation.

No longer can the serious gallery ignore the mass audience that is coming through its doors. The time may not be ripe for you to launch into the more flamboyant forms of promotion, but be aware that times are changing.

ARTIST TIP: The general public is hungry for a personal connection with the artist, to know what it is like to live the creative life. Many artists have successfully connected with collectors by sharing a personal interest other than art, such as playing accordion at an open studio event, leading an art tour to Italy or France, or cooking for a charity.

4

BASIC PUBLICITY TOOLS

In the field of publicity, as in any other field, the first thing you must do is to become familiar with the jargon. This book introduces you to the vocabulary of publicity, so that dealing with the media and with other publicists can be on a professional level.

Beyond this, I strongly recommend that you develop certain basic publicity tools for your gallery. If you don't have time to do this work in-house, you might consider hiring a PR professional. This help will pay for itself in the long run, because once you have these tools at your fingertips, you will be able to respond to a great many more publicity opportunities. Many of these tools, such as the media list and background releases on the gallery and the director, have a long shelf-life; they are done only once and then updated periodically, or they are specially tailored when you want to target particular media.

Each is discussed in detail in later sections, but they are listed here:

- An up-to-date local and national media list (see page 34)
- Photo files and a clippings file, including digital versions stored on a CD (see page 40)
- A library with samples of all the publications in which you advertise and which are targets for your publicity (see page 44)
- A background release on the gallery or on the director (see page 99)

- A generic publicity package or press kit for your gallery (see page 47), which you can tailor to individual situations as they occur, and that contains a press release, photos, and a biography press release or fact sheet
- Press release stationery and photo caption labels, both hard copies and digital versions stored on CD (see chapter 11)
- A Web site that announces upcoming exhibitions but also includes a mission statement for your gallery; a press room for current releases and an archive of previous press releases and reviews; and profiles of each artist, including digital photos and a brief biography

Developing a Media List

Your publicity is only as good as your media list, and you should give careful attention to developing a basic list that fits your needs. It is costly to send releases to too many media outlets, and editors and writers toss out material from sources that have been useless to them in the past.

> **TIP FOR GALLERIES:** See if you can borrow the media list from another gallery or even another arts organization. Then customize the list for your needs.

Your list will be determined by your location, your type of gallery, the range of your artists, and the scope of exposure you are seeking. The Internet is an excellent source of information on just about everything, including media sources. Most libraries have copies of media directories that list all the newspapers in a city or all the trade magazines in a particular area. Other directories will give you all the radio and television stations. Most published media directories now have an online counterpart.

Over the last fifteen years, with the integration of the Internet into everyday life and business, the accuracy of media directories serving the professional publicist has greatly improved. Online media directories offer the advantage of more current information, as they can be continually updated with changes in media contact information, editorial deadlines, or contact preferences. Written directories, while still produced, tend to go out-of-date quickly, because updates are more infrequent and costly. Some of the directories offer PR professionals in different fields customized media lists, such as music media contacts for the PR firm for an emerging rock band. Bacon's, found online at *www.bacons.com*, provides both subscription services and pay-as-you-go

access to comprehensive media lists. You can also use free online media lists, such as *www.mediadir.com* or the Columbia Journalism Review MediaFinder, *http://archives.cjr.org/mediafinder*. See appendix A on page 159 for further leads on media directories to search.

Most media directories will provide you with not just names and categories of media sources but also much of the other crucial contact information you will need for your media database. When possible, get all of the information you can from the media directory and then call the media source directly and ask for (or confirm) the following information:

- Correct mailing address
- Copy deadlines
- The names of the art editor, calendar editor, entertainment editor, correspondents, and stringers who may have an interest in arts and cultural events
- At radio and TV stations, the names of the public service director and the assignment editor

Note that getting copy deadlines and scheduling your releases accordingly is crucial. A monthly magazine may have a deadline as much as four months before the date it is published, while a daily newspaper can insert an item the night before the paper appears.

If you are doing a lot of national publicity you might consider purchasing the following books. See appendix A for a full listing.

Broadcasting/Cablecasting Yearbook
1705 De Sales Street, NW
Washington, DC 20036
www.reedref.com

Editor & Publisher International Yearbook
Editor & Publisher
770 Broadway, 2nd Floor
New York, NY 10003-9595
www.editorandpublisher.com/yearbook

Gale Directory of Publications and Broadcast Media
Gale Research Inc.
Thomson Gale
27500 Drake Road
Farmington Hills, MI 48331-3535

National Radio Publicity Outlets, and *National TV Publicity Outlets*
Public Relations Plus, Inc.
P.O. Box 1197
New Milford, CT 06776
www.mediafinder.com
www.yearbooknews.com

Media Categories

The following is a list of the main categories you will want to consider in your media list:

- Daily and weekly newspapers
- Local bureau offices of national media
- Monthly newspapers
- Art publications
- City publications
- Wire services

Send to all of the above: all releases on exhibitions, events, and gallery news

- Specialty publications that cover the arts (Architecture, Interior Design, House and Garden, Lifestyle, Fashion, Culture, and so on)

Send: releases of relevance to their audiences

- Foreign language publications and periodicals

Send: releases on foreign-born artists

- Social press (daily, weekly, monthly newspapers, and magazines)

Send: invitations to artist openings and all special events; work that has a "society" theme (portraits by Richard Avedon, for example)

- Freelance writers

Send: releases and catalogs pertinent to your target media

- Radio and television stations

Send: all special events material to community calendar programs to TV and radio assignment editors

- E-zines
- Art newsletters
- Art-related Internet sites

General Scheduling Guidelines

Listed on the next page are some general guidelines for various media, but rather than relying on these guidelines, call your local media to be

sure. Deadlines vary with each newspaper, station, and magazine. For most galleries, the media located within a hundred miles of their location are the most potentially valuable for audience development. This, of course, can vary depending on the nature of the gallery and whether it is located in a rural or urban area, but the point is to get the most accurate, up-to-date information on all media important to your business. Information to be sent in advance:

Daily Newspaper . 1–3 weeks
Daily Newspaper–Calendar Editor 1–3 weeks
Weekly Periodical . 3–4 weeks
Weekly Periodical–Calendar Editor 3–4 weeks
Monthly Paper . 4–6 weeks
Monthly Paper–Calendar Editor 4–6 weeks
Monthly Magazine . 3–6 months
Monthly Newsletter . 4–6 weeks
Art Trade Magazine
 (for feature articles and major reviews) 3–6 months
 (for exhibitions) . 6–8 weeks
E-zines . varies

Organizing a Media List

Most galleries have their media list in a computerized database. Each media person/outlet should have a separate entry so that notes and comments about the person's preferences can be added—schedules, interests, preferred methods of contact, and so on. Most contact management programs or database programs allow you to assign each entry to various categories and sort the entire database to allow you to view entries that meet specified criteria. This will allow you to quickly tailor your list for the needs of each project, as well as to find a single entry without reading through the entire database.

Database software such as FileMaker Pro, Pressfile, Outlook Contacts, and Excel will enable you to keep your media list organized and easily updated, and your media contact strategy efficient. Of these programs, Pressfile (*www.pressfile.com*) was modeled after FileMaker Pro and specially developed by the Florida-based "Small Company" for the needs of publicists.

Several of these programs will allow you to send e-mails directly to the contacts in a sorted list, as long as they have e-mail addresses on file. You can also use the mail merge feature in your word processing program to send hard copy mailings to a large number of addressees without customizing each document by hand. You write the document,

placing field codes in the places where the variable information will go. When you merge the document with your database group, the relevant information in each entry in the database replaces the corresponding field codes in the document, creating a whole batch of customized and addressed documents.

Media List Entry

Name:
Publication/Station/Institute/Program:
Name and title of contact person:
Address:
Phone:
E-mail address:
Web site address:
Notes: Keep information such as:
- Schedules (how far in advance to send timely material)
- What kinds of material to send
- What format should be used to send digitalized material
- Special interests, likes, dislikes
- Record of media coverage from this contact
- Notes on attendance at events and on inquiries

Keeping Your Media List Current

At least once a year, preferably every six months, update your list. Here are some suggestions:

1. Call or e-mail key publication and periodical media contacts to make sure that your information is current. It is not necessary to contact the local art critic if you are reading his or her column every week, but you may not be in constant contact with some of the event and calendar editors. You should note in your media list database how they prefer to be contacted for such updates. While e-mail may be more convenient for both you and the contact, sometimes nothing creates a personal relationship with a contact faster than an efficient and friendly

phone call. This is also an opportunity to ask if the contact has visited the gallery. Remember, too, that calendar editors become valuable sources for future PR and for information.

2. With your next release, you can try sending out e-mails or return-postage-guaranteed cards (according to their preference) to all independent art writers and institutions on your list, asking them to correct any mistakes in the names or addresses. However, most media sources will not send such changes to you on their own initiative.

In the beginning, your media list will just be a collection of strangers' names, but once your program is underway, you will probably find that you are working with the same critics and editors again and again. Soon, keeping the list current will not seem like such an overwhelming task.

What Media to Target

As you develop your marketing goals, identify your target audiences. For each of these audiences, consider what media they follow. What are they likely to read? It is sometimes helpful to ask yourself, "If I were going to advertise, where would be the best place to reach this segment of the community?" Then refer to the publication's own media kit (described on page 44) to see if it confirms your intuitive response.

Don't simply bombard your entire media list with every release. By streamlining your media outreach, you can use your energy and money to best effect. Remember—you lose credibility with editors if you continually waste their time with releases that are not relevant to them.

Don't forget to include publications and outlets that target specific populations such as Hispanics, African Americans, Asians, gays/lesbians, parents and families, and kids. These media should be considered for every exhibition and certainly if those populations may have a particular interest in your exhibit or event. If you contact media that reach distinct groups for topical exhibitions only, your interest in their coverage may look pejorative. Inviting them consistently sends a message of inclusion (and conveys a message you want to send that any kind of art can appeal to any kind of people, not just art produced by people like them).

Take a Hard Look at Your Offering

Many galleries want local art critics to cover their exhibitions but are not realistic about the appropriateness of their offering for critical review. Try to be objective in assessing whether your exhibition would interest that particular critic.

For example: A gallery representing folk artists from a particular historical period in China may have quality exhibitions, but art critics and writers who are reporting on current American contemporary art trends will not be responsive. However, there are other media angles to pursue, such as collector-oriented, Chinese language, folk art, and arts-and-antiques publications, as well as lifestyle and special interest magazines.

Setting Up Your Files

You will want to have easy access to all of the publicity materials you have sent out to your media contacts and all of the clippings of coverage you have received in the press. Having computerized files is essential; it helps you respond easily to publicity opportunities, ensures accuracy, avoids duplicated efforts and embarrassing mistakes, and so forth. Having digital copies of all of your documents and photos allows you to post them on your Web site if you wish and to transmit them to the media or other contacts via e-mail. Make sure to make regular backups of all of your files for storage on CD. This prevents you from losing information in the event that your computer is disabled by a virus or technical problem. It may also be useful to have hard copies in display notebooks that you can carry with you or that will be accessible to any member of your staff at any time. This is important, as art press releases are sent out many times after exhibitions to collectors and to media needing background info.

Press Release File

Ideally, all press releases should be accessible to all of your employees either on your Web page or on your computer network on a read-only basis (meaning that some users can view the entries but not change them). This allows them to be immediately responsive to all inquiries about the releases.

However, if your computer system is not networked and you don't yet have a Web site that your employees can access, set up a file in chronological order, using a three-ring notebook, with all the media releases you send out from the gallery. This file, if it is kept in a handy place where everyone can find it, assures that simple inquiries by media people can be answered promptly by any staff member. For instance, you want to avoid keeping an art critic waiting an interminable time while someone rummages around trying to find the correct spelling of the school your artist attended, just because your publicist is at lunch.

Artist Files

Each artist represented by the gallery should have:

- A hard copy and digital media file containing copies of all press releases and photos—these can also be made available to the public and the media through links on that artist's page on your Web site
- A chronological file of all press coverage (if you have a scanner it may be worthwhile to scan in the clippings so you can store them on your computer)

Keeping Track of Your Coverage:
Scissors and Clipping Services

If you have the funds available, you can hire a clipping service to monitor and send you copies of all of the press coverage you receive. Clipping services can cover written publications as well as radio, TV, and Internet publications, even Web "chatter" in chat rooms and listserves. Or you can monitor these media for coverage yourself.

You must regularly read, visit, watch, and listen to your media sources. This is part of the publicist's job even if you do use a clipping service. Learn what each publication and media outlet as a whole tends to cover and what their style and editorial point-of-view tends to be. Note what a certain writer who covers the artworld has been writing about recently and what that writer's particular interests and pet peeves are. You are much more likely to be successful in your story pitch with that writer if you can show knowledge of his or her work in the past. "I loved your story about X last week. I have a story that ties in with that theme…" Even if there is no topical connection between what the writer has been writing and what you are trying to pitch, demonstrating that you have done your homework has great "schmoozing" value with the contact and will help turn him or her into a media ally.

Press Clipping File

Clippings of critical reviews and feature articles are good sources of quotes for future releases and are an essential part of any serious artist's career development. Set up this file alphabetically by artist. You will also want a section of the file for general press clips on the gallery and the director.

To keep accurate records for future bibliography updates, label each clipping with the following information that has been checked for accuracy from the actual source:

- Title of article (or headline), byline (writer's name)
- Name of publication, volume, date, page(s)
- Managing editor's name (if no byline)
- Note and describe illustrations in the article

This may look like a lot of work, but in the end it's a great timesaver. You can create labels in most word processing programs, and print from your computer printer directly on labels that you can then peel and stick right on the clipping.

Press Clipping Label

Title of Article:

Byline:

Managing Editor's Name (if no byline):

Pages:

Name of Publication:

Volume:

Date:

Illustrations or Photos:

B/W or Color:

Captions:

Photo Files

Slides and prints from media photographers should be bought in digital form as soon as possible after they appear in print. Copies of the digital photos for each artist should be kept in the artist's file on your computer, possibly in different digital formats and resolutions. Captions for each photograph should be saved in the same folder as the photograph, and they should always be sent out together, whether in e-mail or through the mail.

A hard copy photo print file for each artist, together with related caption information, can be organized by main subject headings, such as:

- Black-and-white of artist at work
- Portrait of artist standing with work
- Color slides of art

Signed release forms should also be scanned in and saved with the photos, along with information or any restrictions there may be on

photographs you have purchased from a media outlet or photographer. Every hard copy photograph that goes into a file should have a label identifying it. (See "Format for Photo Caption Labels" in chapter 13.)

Photo Release

I hereby grant permission to use my photograph for promotional purposes. The photo may appear with or without the use of my name.

_____ _____

Signature Date

Address:

Electronic Broadcast File

Write and save a summary of each interview, public service announcement, feature, etc., along with scanned and original copies of any correspondence. Note the day, month, year, and time of the broadcast. Include all the different contacts you made on the program. Make an effort to get copies of tapes and transcripts, and label them, keeping them all together chronologically. (See chapter 6 on working with the electronic media.)

Public Speaking File

Keep copies of your presentation notes, copies of any PR announcing the lectures, and summary documents detailing where, when, and to whom you gave the presentation. If you have digital audio or video files of your public speaking engagements, you may want to make portions available for public viewing on the gallery Web site.

Marketing Advertising File

Keep a digital and hard copy file of all direct mail letters, brochures, newsletters, important e-mails, specialty advertising and paid ads, and screen captures of any Web advertising, with the price and date used noted on each. This is helpful in planning future marketing campaigns and for budgeting projects.

Publicity Library

Develop a library of samples of (and a list of Web links for) those publications in which you advertise and from whom you are seeking publicity. Having all these periodicals and publications at your fingertips is a great timesaver.

You can receive a free copy of almost any publication by sending it a letter or e-mail saying you are interested in advertising. Most major publications have kits they will send you that profile their readers, describe their publications in detail, and give their ad rates. This information is geared for advertisers, but it also serves those wanting to place articles or generate reviews. Some reader profiles go beyond income and employment categories to hobbies and even the contents of investment portfolios! *ARTnews*, for example, posts basic advertising information and reader profile on its Web site at *www.artnewsonline.com/advertise.cfm*, and provides a form to request a full media kit.

You will be much more inclined to do research and, therefore, to have a more carefully focused publicity campaign, if someone doesn't have to rush out to buy relevant periodicals. If you can't obtain a copy of the newspaper or magazine, photocopy an article for your files, along with the masthead page, so you have the names of all the different editors you may want to contact. Use this information to keep your media contact database up-to-date.

5 WORKING WITH PRINT MEDIA

The media and businesses in the arts are like the rhinoceros and the tickbird: They need each other. Businesses connected with the arts rely heavily on publicity and critical comment for their success. For this reason, they need to cultivate an unusually close relationship with the media. The media, in turn, rely on information as the raw material for their stories and appreciate a high level of professionalism in their sources, since it makes their own efforts easier and their final product better. Grace Glueck, art critic for the *New York Times,* has said that it is important for public relations people to know they are valued as fellow professionals.

If they understand our problems of space and deadlines, the need for accuracy and really newsworthy stories, they will have us knocking on their doors.
—Grace Glueck, quoted in "The Public View,"
International Council of Museums

Just as your clients come to trust you because you make an effort to know what interests them, so your media contacts will come to trust you because you make an effort to know them and the way they work. In the beginning, this may seem impossible—all those strangers in an unfamiliar world—but you will find that you work with the same critics and editors again and again, and soon they will become friendly faces, or at least friendly voices on the telephone.

Appendix B gives you a quick rundown on the different people in the media and what their jobs entail.

Gaining the Media's Trust

The media are in the business of communicating verifiable information and facts of interest to their constituencies. In the case of art writers and critics, they also convey their opinions and observations. Keep in mind that publicity coming from your gallery must be information that editors, art critics, and writers can trust so that you become a source they respect.

Developing a Relationship of Trust is Critical to Any Successful Publicity Campaign

The first step is to research and address each media person by his or her proper name. When the calendar editor of your local newspaper gets a communication addressed "Dear Datebook Editor," it is like receiving an advertisement addressed "Dear Occupant."

All dates, times, facts, and names in your press releases should be correct. Double-check them to be sure. If details change after the release has been mailed, you should notify your editor, writer, or critic immediately. This will demonstrate your concern for accuracy, on which the media rely. If time permits, send an updated press release. When the date of an opening is incorrect and people find the gallery closed, they tend to get angry at the newspaper that published the information. You can see why it's important to protect the media from your mistakes.

Assume that the recipient of your mail is under tremendous time pressure. Your release should be a self-contained document that has all the routine information. Although you may send along an invitation, a catalog, a poster, or an announcement, you should never expect your media contact to hunt through these extras for essential information.

Most gallery publicists are too busy to follow up each press release with a telephone call, but if you feel an exhibition is especially noteworthy or would be of special interest to a particular media person, a personal call can be helpful. Remember, however, that the reporter may not even recall receiving your release. Prepare a few notes on what you want to say and have a copy of the release in front of you. Your purpose is to remind your contact of the release and to spark interest. You should never ask directly if an individual is planning to cover an exhibition or try to nail down a commitment to come to the gallery. If you are asked to send photos or additional information or another copy of the release, do so as promptly as possible, adding a cover note referring to the conversation.

The Importance of Ready Information

Whoever handles the publicity for you must be well informed about everything that concerns the gallery and its activities. The media must be able to call their gallery contact and get legitimate information as quickly and reliably as possible. A good feature or review may depend on it.

One famous art reporter complains that publicists often fail to respond even to simple requests for information. He expects a good publicist to provide "an efficient service of incidental information"—the dates of a past exhibition, where the artist studied, and when a piece of art was acquired by a prestigious museum, for example.

Small things—mundane questions answered quickly and effectively—create a good impression at the other end of the telephone. When, subsequently, you have something important to announce, the journalist will start by being well disposed to what you have to say . . . That kind of willingness to listen cannot be bought by a thousand expensive lunches.
—Charles Collingwood, Arts Reporter, London, quoted in "The Public View," International Council of Museums

Gallery Press Kit for Print Media

A basic press kit for the gallery is an invaluable promotional tool and not difficult to put together. It establishes your identity and credibility with media people who may be unfamiliar with your gallery. It can be updated as new shows and artists are added. If you want to create a kit, include the following:

- Black-and-white photograph of the gallery, giving an impression of its size, appearance, and inventory (avoid wide-angle shots)
- Black-and-white photograph of the director in the gallery with a piece of art
- Background press release on gallery
- Fact sheet of exhibitions, artists represented, inventory specialties, overview of programs, events and services, daily hours, directions
- Reprints of any press clippings on the gallery
- Optional: Fact sheet highlighting special programs or community activities
- The director's and the publicist's business cards (including Web address as well as street address)
- Reproduction of your Web site home page, if it's instructive, i.e., sampling of artists represented

Distribution Plan

Your press kit can be adapted for whatever publicity opportunity arises. When you have a feature idea, send a press kit on the gallery as well to establish your credibility. Have the kits available to give out to interested media and to introduce the gallery to new media.

For instance, whenever you plan a gallery move or a major renovation, take the opportunity to communicate with the press and to restate the goals of the gallery. The press kit for Security Pacific's new exhibition gallery in Orange County included four releases covering different angles of interest to different segments of the media:

1. SECURITY PACIFIC GALLERY, SOUTH COAST METRO CENTER, OPENS IN JUNE WITH "ART IN THE PUBLIC EYE"
2. ARCHITECT CREATES MINIMALIST LANDSCAPE FOR ART
3. THE ART PROGRAM AT SECURITY PACIFIC CORPORATION
4. ORR, ALBUQUERQUE AND FINE: MESHING ART WITH ARCHITECTURE

—Courtesy of the Cultural Affairs Division of Security Pacific Corporation

Background Press Kit for Artists

Savvy galleries create background press kits for all the artists in their stable so that if a collector, curator, or member of the media shows interest, they will have a kit readily available to give them. These kits differ from other kits in that you should not include dated material or releases in them. Every artist in the gallery should have such a kit that can be given out at a moment's notice. It might include:

- Background press release on the artist
- Reprints of important media coverage
- Past exhibition announcements
- Artist résumé and bibliography
- Artist statement
- Current visuals or CD of work

Working with Feature Writers

Feature writers do stories of general interest for their readers. They expand on the news, providing background material or portraits of interesting personalities. While their stories are not critical reviews, they

can bring your gallery to the attention of a wider audience. They will usually not know much about your business, and they will surely not know it as well as you do, so they will rely on you for an overview and to help focus the important issues of a story.

Like all media people, feature writers are usually harried, and the intensity of their stress is even more acute if they have daily or weekly deadlines. It is not unusual for a newspaper writer to be given two or three assignments at the beginning of the week and then to have to handle another hot story that breaks in the middle of the week. Given this sort of frantic schedule, they will appreciate whatever you can do to make their job easier.

The News Hook

From reading newspapers, you are probably aware that most feature stories have some angle, some "news hook," that draws the reader in. The news hook may tie the story to a current event or bring up an intriguing fact that gives the piece an interesting twist. Media people are often too busy to draw these connections between your straightforward informational release and what is newsworthy and of interest to their readers.

Whenever possible, try to develop the various potential angles of a story in advance. You can include a cover letter with your general background release (see page 99 for a full discussion of preparing a background press release) suggesting a few different news angles. Better still, develop three ideas for the same publication and then, after a brief phone conversation with the feature editor, you can focus on the one that seems to be of greatest interest.

For example: Around the time glasnost was making headlines, a contemporary gallery in Los Angeles was planning an important exhibition of the work of an avant-garde Russian artist and thought the show and the gallery's involvement in Russian art might have potential for a feature article. Here are the different angles the publicist might have come up with:

From Russia With Love—Soviet avant-garde art exhibition opens same week that General Sergei Tolsten is in town to arrange cultural exchanges with Los Angeles' sister city, Kiev

Cultural Glasnost—Russia opens the doors for rare avant-garde art to be exhibited in the United States

Glasnost LA Style—Los Angeles gallery director Mark Tokin arranges major exhibition of Russian avant-garde art

Controversial Russian Artist's Work—seen in the United States for the first time

Any of these ideas could be developed into a feature article. By taking the time to tie the exhibition into a timely event, the gallery has turned an exhibition that would normally have interested only the art media into a mass-media item.

The public, and even collectors deeply interested in art, enjoy stories with a human interest angle. Not everyone is up to reading formal art criticism over morning coffee. A feature story can be just the teaser to motivate a client to pay a visit to the gallery. Such a story should not be overlooked just because an exhibition is also worthy of critical review. The two serve different purposes.

Be alert to potential stories for newspaper departments other than the cultural news section. Consider financial, travel, or society angles to any activity concerning your gallery.

Getting a Successful Story

If interested, the feature writer will contact you for an interview. You can assure yourself of having the story accomplish what you want it to if you prepare a narrative outline for the feature writer before your interview.

Based on the news angle that the writer will have already accepted, the outline should give, in a concise and accurate way, all the pertinent information that he or she might hope to gain from interviewing you.

Because of the extraordinary pressures on the press, there are inevitable mistakes, misquotes, and inaccuracies in many printed stories. With this outline in hand, the writer has a backup if his or her notes prove to be incomplete or, as is often the case, indecipherable.

Prepare this outline before the interview, then send a follow-up sheet to the writer afterward, covering any new angles or questions that came up in the interview. Also enclose suggested photo captions for every picture that is taken.

The form of the outline may be whatever is most appropriate. For example, if the story is consumer-oriented, you might frame it in terms of the most frequently asked questions. Never try to write the article for the journalist. That would be an insult. But by providing the essential information in a concise form, you will improve your chances of being the story that is covered rather than the story that is skipped because of a time crunch.

Exclusive Press Interviews

When you have a famous artist, personality, or curator coming into town for an exhibition, you may want to consider offering an exclusive interview. Consider first what media will be likely to reach the people you want to reach. Give some thought to which person at the publication (or television or radio station) would be most interested in doing

such an interview. At a daily newspaper, for example, the art critic might not be interested in the interview since it would be outside the format for the review column. Instead, it might be the Sunday feature editor for the arts section.

Before you send out your general publicity, mail a press release to your first choice, either enclosing a short cover letter offering an exclusive interview or following up your release with a phone call offering such an interview. If this contact decides not to do the feature, follow the same procedure with your second choice.

Letter to Feature Editor Proposing
Feature Article and Exclusive Interview

Michelle Rubois Gallery

36 E. Kellogg, Minneapolis, MN 55101 ■ 612-823-6000

Dear (Feature Editor):

We have just finished installing the largest exhibition of contemporary European craft artists that has ever been attempted by an American gallery. The show was curated by Andre de la Tour of the Musée de Campagne in Paris. More than 60 pieces are on display.

Knowing of your readers' interest in keeping abreast of current art trends, we suggest a story on the curator who supervised this project and who will be in town for a series of lectures at the gallery and the Art Institute.

M. de la Tour is an articulate interpreter of the contemporary crafts movement. As you know, in the last decade there has been a redefinition of what is considered craft and what is considered fine art, which has greatly affected the cost of both functional and nonfunctional work. Unfortunately, it has also created considerable confusion in the minds of collectors. I think your readers would find it both interesting and helpful to have these gray areas cleared up.

I have enclosed a background release on the exhibition and a résumé on M. de la Tour. Please let me know if you would like additional information.

We are offering this story to you on an exclusive basis and will look forward to discussing it further with you.

Cordially,

Danielle Trendall, Publicist

One Sobering Thought

When you and the feature writer have both done everything impeccably, the story still may not make the pages of the newspaper. Stories often get killed when major events occur, like a natural disaster or a plane highjacking. In fact, art pages are routinely taken over in daily newspapers for any number of reasons. It is one of the trials of art organizations—hard news pushes art news off the page. But remember that the relationship you've developed with the writer may be more valuable than the story that got killed. He or she is likely to remember you in the future, and a new tack might even be developed on the same story.

Working with Art Writers and Critics

Critical reviews are essential to the development of any serious artist's career and to any serious gallery's reputation. A local critic's review of your exhibition or an art writer's piece about a new movement in which your gallery is involved could be the brass ring of your publicity effort.

Although art critics and art writers share with other media people the need for trustworthy information, they are distinct from newspaper feature writers and, indeed, from each other. It will be useful to have a clear idea of the function of each, so that your approach will be on target.

The Art Writer

A feature article on some general art subject, appearing in a monthly publication, will typically be the work of an art writer, who usually has an extensive background in art history.

You can contact art writers when you have some unusual news that might interest them, such as a cooperative effort with other galleries representing artists of a new movement. It's wise to give them at least six months' lead time. (Your media list—see page 37—notes each medium's lead time.)

The final decision on what to include in a national art magazine is usually made by the managing editor, who will often base the decision on the timeliness of the story—for example, an artist who is really hot or is part of a new art movement.

It is important to have on hand a good list of freelance art writers. Ideally, they will have solid contacts with publications. If an art writer is unfamiliar with an artist you represent, send along a color reproduction of a recent work by the artist, or an exhibition catalog.

There are companies that specialize in art-trade mailing lists of specific categories of people, such as art writers, critics, or museum curators. Look in the classified section of your regional and national art publications for a listing of art media mailing list suppliers. Also, the British publication, *Arts Review Year Book*, published by Arts Review (69 Faroe Road, London

W14, England) includes a guide to British press, television, and radio arts editors and reviewers. The Italian publication *Art Diary* lists the names and addresses of art critics and writers around the world.

A sample from the *Art Diary Critics/Critici* section is excerpted below, courtesy of the editor and publisher, Giancarlo Politi (68, Via C. Farini, 20159, Milan, Italy).

Page from the Art Diary

SPAIN (34) / BARCELONA (03)

CRITICS / CRITICS

Blanch Maria Teresa, Sardenya 521, 08024 - Tel. 219.6260

Borras maria Luisa, Conseill De Cent 369, 08009 - Tel. 247.5612

Bosch I Mir Gloria, Escoles Pies 25, 5o 1, 08017 - Tel. 200.7463

Camps M. Teresa, Pou Claris 181 - Tel 215.3137

Clot Manel, Pl. Maluquer I Salvador 6, 1a, Granollers, - Tel. 870.6740

Combalia Victoria, Dexeus, Doctor Carulla 60, 2o 1a, 08017 - Tel. 212.4560

Corominas Maria Jose, Asturies 17, 08012 - Tel. 218.2198

Coredor-Matheos-Jose, Astures 17, 08012 - Tel. 213.0878

Dols Rusinol Joaquim, Valencia 202, 08019

Doran Manuel, Ronda del Guinerdo 28, 08024 - Tel. 213.7466

The universe of art writers is relatively small, and there is a network to which you can fairly easily gain access. Art writers may be reached in care of the magazines for which they write, and your local newspaper or regional art publications should be able to give you some names. Another source is the local museum's publication department. And major galleries often have lists of writers they call on to do their catalogs.

The Art Critic

Critics are interpreters of the cultural condition, not just announcers of art events. An exhibition must be a serious endeavor to be worthy of critical review.

A reminder: Criteria used by critics for covering an exhibition may vary considerably, depending on their perception of what is relevant to their audiences. Such things as the stature of the artist, the stature of the gallery, whether the exhibition is an example of a particularly interesting trend, or whether it carries political overtones may influence them.

Daily newspaper critics on the gallery beat will most likely be interested in covering important contemporary exhibitions. They will be unlikely to review an exhibition of an artist who works in the style of, say, the Impressionists. On the other hand, an art critic for an antiques magazine may review the exhibition, since contemporary art in that spirit is often of interest to collectors of antiques. Critics for local publications will feel more commitment to cover local artists and regional movements than will critics writing for national magazines. The major art magazines tend to be interested in covering artists and movements that already have established national reputations. The exception is when a writer is sent to a region to report on interesting new artists.

An art critic responds to a specific exhibition, and responds quickly because of deadlines. This person usually has some background in both art history and journalism, but becomes a major art critic only with experience. From time to time, an accomplished critic will write catalog essays or serve on an art-judging panel. Occasionally a critic may even curate an exhibition.

In areas where art reporting is not a high priority of the newspaper, the art critic may be a business or sports writer who got bumped to the art pages. Rather than actually writing formal art criticism, the writer will lightly edit or print verbatim what galleries or museums submit.

Newspapers have different methods of deciding what art features and reviews to run. Often the art critic makes the decision about critical reviews, submitting a list of story proposals for the coming months.

It's best to contact art critics three to four weeks before the exhibition or event, and then follow up with a telephone call. A monthly paper usually has a two-month lead time, but you should have the specific information for your local critics in your media list.

On Being Perceived as a Serious Gallery

In many communities today, the art critics are unable to keep pace with the proliferation of galleries and alternative spaces. A subtle selection process occurs based, first, on whether the gallery is perceived as being serious (i.e., worthy of review) and, second, on whether the gallery staff is cooperative. The article reprinted on page 55 from the *Los Angeles Times* gives you a perspective on some of the ways critics assess a gallery.

In a competitive environment such as the San Francisco Bay Area, where there is not even sufficient room in the Sunday calendar section to publicize all the galleries worth listing, the calendar editor uses high standards of selection. Just because a gallery mounts three or four serious exhibitions a year does not guarantee it status as a serious gallery. An example of this subtle "survival of the fittest" assessment by the art media is a major newspaper's editorial policy of not reviewing a gallery until it has been in business one year and has consistently demonstrated its worthiness of critical attention.

The excerpt below may give you some insights
into critics' attitudes in general.

How to Discern Sophisticated
Art Galleries from Brand X

In a recent article in the *New York Times*, an art critic was discussing whether the Martin Scorsese film *Life Lessons*—about a middle-aged painter and his girlfriend-cum-studio assistant—seemed true to real art-world life. The critic decided that the film was quite accurate, but a few details bothered her. One was the size and bulk of the letters that spelled out the artist's name on the wall of the gallery where he had his retrospective show.

"They're big and they're in relief," she wrote, "and in an artworld where the sleekness of press-type or painted lettering is *de rigueur*, they signal a less than first-rate gallery, as does the aggressively unsleek, barnlike space of the gallery itself."

Such are the seemingly nit-picking things that take on intense meaning in the frankly snobbish and ultra style-conscious world of contemporary art. So if some of the following tips for spotting a first-rate art gallery—as opposed to the more populist variety—seem odd, bear in mind that this is truly a world unto itself.

The salespeople allow you to browse on your own. They may ask if you have any questions but they don't shake your hand, ask you how you are, and to try to sell you something.

Prices generally are not posted next to the work. They are either on information sheets available at the front desk, or you are obliged to inquire about them.

The works are hung or placed at reasonably spacious intervals (not stacked on top of each other) in a well-lighted, open space, generally with walls painted white or left bare.

If the artists the gallery represents are established, they are likely to have been reviewed in the three major U.S. art magazines: *Art in America*, *ARTnews*, and *Artforum*, or in California-based *Artweek*, *Visions*, *Art Coast*, or *Art Issues* magazines. Ask the gallery for copies of reviews.

The gallery's press materials may include mention of museums in which the artist's work may be found but never of celebrities who own the work. Artists are *not* referred to as "world-famous" (if they are, it is assumed you will have heard of them).

Gallery staff does not use the phrase "original oils" or "original acrylics"—all paintings are presumed to be one of a kind and original. Rarely will gallery staff mention how much time an artist spent making a work or how costly the materials are that the artist uses. In artworld terms, those are not valid ways of measuring the inherent value of a work.

—CATHY CURTIS

Once a gallery has been perceived as not being serious, it may take years of consistent effort to reestablish credibility. While it is important to keep your name before the critics, it is counter-productive to send releases on shows that will develop a negative image for the gallery.

One California gallery alternates serious exhibitions, worthy of critical review, with more decorative or frivolous shows. To the dismay of the director, no serious art critic has been in the gallery for years. In this situation, the gallery director might consider any of the following strategies:

- Make a commitment to exhibit only serious work or have only serious work in the main gallery.
- Send press releases only to the art critics who are appropriate for their coverage. This is a judgment call.
- For a seemingly frivolous exhibition, such as children's book illustrations, develop the publicity more from a cultural or human interest perspective, or do the extra research to demonstrate that the artwork does, in fact, have critical merit and has received critical coverage in other media. Even attach a copy of a previous review.

Staff Attitude

One of the biggest complaints of critics and art writers is that gallery employees often seem indifferent to them, and may even be annoyed when asked to hunt for background information on an artist.

"When I have two days to find a show I want to write about, if I can't get information, it dissuades me," says Elizabeth Hess, art critic for the *Village Voice*. "One gallery that really stands out in my mind follows up a request for information with a whole little box: slides, reprints of articles, reviews, catalogs, fact sheets—the whole works."

Getting the Critic to Visit Your Gallery

Sometimes critics simply overlook the smaller galleries. If you are located off the beaten path, it may be more of a challenge to get those important-to-you media visits. Usually, with a little prodding, you can get a critic to come, as long as your offering is worthy of attention.

For example, a gallery director in a town just outside a major metropolis had an outstanding show that she was quite sure the top local critic would like. She sent him the usual press release, with a short, personal, printed cover letter.

Dear Mr. Temple:

I have enclosed information about the artist whose paintings will be in the gallery during the month of May. I believe you have seen some of these before, but in this show the whole series of (series name) will be presented at the same time. I think (artist's name) is an exceptionally innovative painter, and I hope this show will bring you to (name of town) for the first time. I think it will be well worth the trip.

Best wishes,

The days went by and no critic. Then she sent him the following handwritten letter:

Dear Mr. Temple:

I have been operating the (gallery's name) for the past five years and have progressively shown more and more serious work. During this time, I have sent you press releases and invitations, but as far as I know you have never been here.

I know you are terribly busy and have a hectic schedule, but this month I have a show that I think is particularly outstanding and one that is worthy of your critical attention. I would like very much for you to see it.

I know it is impossible to know what you will find of interest to review, but I think (artist's name) work has enough strength and technical innovation to make it worth your while.

She went on to suggest that they have lunch. The critic came on the last day of the show.

Personalizing Your Relationship with the Art Press

The world can be an empty place if you don't make personal connections with people along the way. This basic human value is often overlooked when it comes to art critics and writers. They frequently are cast in the role of adversary, when in fact they are just people who happen to make their living writing about art. Most critics have a basic need to personalize their work relationships, to feel a part of the art community as well as a commentator on it. Of course, among individual critics you

will find a wide range of personalities. Some may not want to chat, and others may want to go in your back room, kick up their feet, and gossip about the artworld over a tuna sandwich.

Aside from personal preferences, a critic or art writer wants to feel welcomed and respected. If your staff person groans or acts aloof when asked to hunt up some past articles, the message is: "You're a nuisance." If the information given turns out to be inaccurate or is not prompt, it's an indirect way of saying "I don't respect what you do." If a dealer is pushy or over solicitous, it may make the media person feel manipulated.

On the other hand, if you reach out to a member of the media in the same way you might to a friend of a friend whom you are preconditioned to like, soon you will find you are on the way to building a relationship of professional trust and respect, and perhaps a friendship as well.

Press releases should be able to stand on their own, without a cover letter. But there are situations where a personal letter can be helpful.

Contacting an Editor with a Feature Idea

When you have explored an idea for a feature article with an editor, a personal note, perhaps handwritten, is a nice touch, and it can help jog the editor's memory about your conversation. Such a follow-up letter might read like this:

Dear (editor's name):
It was nice chatting with you yesterday. I am enclosing the material I promised on the changing role of art dealers and collectors—and I'm also sending along a recent trade article on the subject, which may interest you.

If you have an idea or a perspective that is not related to an exhibition or a specific event but that you think may be of interest to an editor, or if you just want to let her or him know that you exist as a future resource, a brief letter is appropriate:

Dear (editor's name):
As an art dealer who sells primarily the work of emerging local artists, I am frequently asked by young collectors how to assess the relative quality of an artist's work when it has not yet received any critical reviews.

If you would be interested in doing a story on this topic, please feel free to call on me. Some background information on myself and the gallery is enclosed for you.

Attention or Highlighter Note/Letter

If there is some important aspect of an item you are sending out that you want to highlight, or if you want to make sure a particular media person understands why the work might be of interest, a short note can be very effective:

> Dear (art critic):
> Argenti has been a shepherd in Tuscania for most of his life, but he has also developed a reputation as one of Italy's finest poets, taking part in traditional extemporaneous poetic "duels." I think you'll find both him and his paintings vivid and interesting. We're having a small preview on Wednesday from 5 to 7, and he will be reading a few of his poems.

Or you can point out some feature of the show that might suggest an approach:

> Dear (art critic):
> These are Cornfeld's early works, never before exhibited. They are interesting in themselves, but they were also seminal to his later Pop period.

Or a note can be as simple and enthusiastic as this, if you have established a personal relationship with the art critic:

> Dear (art critic):
> This new group of paintings is a knockout—they have that same quality as the "Elegy" series. Hope you get a chance to stop by.

Or even:

> Dear (any of them):
> Do you think you'll be interested in this?

TIP FOR GALLERIES: Always include an advance exhibition schedule (AES) in your press kits. Why? Having an AES helps journalists in planning a feature article, by letting them know when they might need to hire stringers or freelancers, and helps them make connections and recognize trends between different events and shows in various museums and galleries.

- Include the exhibition titles, dates, and a blurb about the project or artist
- List the AES on your Web site and keep current with any updates
- Include press release/press preview invitations schedule for major exhibitions

TIP FOR GALLERIES: Galleries often don't know what they are doing six months out—the sooner you know, the more publicity you can seek. If you are always juggling dates and your artists know that your deadlines aren't firm, then everyone loses valuable opportunities to maximize every PR possibility.

TIP FOR ARTISTS: Always include information about any upcoming shows or new major works in progress in your communications with the media or potential clients. Demonstrating to the media that you have a plan for your career builds confidence in your reputation and professionalism as an artist; it also shows that other people are interested in you and your work, so they should be interested too.

TIP FOR LARGE GALLERIES: It is the publicist's job to prepare curator or artist for press interviews:

- Remember that anything you say may be quoted
- Be professional; treat journalists respectfully by treating them as professional colleagues
- Supply them with all important facts
- Answer the question asked
- When asked a question you don't want to answer, don't answer it, or offer an answer to a question you do want to answer instead
- Practice interviews—give interviewee questions to anticipate

6

WORKING WITH TELEVISION
AND RADIO

When you are going after publicity in television and radio, it is crucial to research what outlet is best for your gallery. News about the arts now fits into few slots in these media, but, as art appeals to a growing segment of the mass audience, arts coverage is increasing in many cities. Television and radio stations are experimenting with new cultural programs, covering their local museums and gallery activities.

This is an excellent time for galleries to learn how to tap into this powerful source of promotion. And you can capitalize on the newness of these programs, before they are firmly established and their criteria become more rigid and more competitive.

Television Coverage

Television exposure is phenomenal compared to print media. In a newspaper with a circulation of 100,000, perhaps only 20,000 people will see your ad or read your feature article, because people tend to read selectively, and some read only one or two sections of a paper or a magazine. But when a television program is beaming into 100,000 homes, the chances are good that at least 100,000 people are going to see you.

The myriad benefits of television exposure include:

- Reaching a large and diverse new market
- Being perceived as an authority

- Building a personal image—if the appearance is handled correctly, viewers feel they have met you personally
- Being presented as a visual image and in color

Radio Coverage

A radio station usually has a specific audience and a specific format. Many NPR (National Public Radio) stations have cultural news reporters for their special weekend shows or cultural news spots as fillers, which serve as radio calendars of events. If you find a program that would be a good forum for your publicity, send a targeted press release to the assignment editor or contact the producer of the program with some ideas for an interview or a story.

Radio is a powerful medium, often underestimated. Members of the audience are free to create their own images as they listen, so a well-written spot or a stimulating interview can conjure up a more complete and intriguing picture than even an expensive television commercial might. The radio audience is growing, and those who listen to public radio stations tend to be those who would be interested in events in the artworld.

Public Service Announcements

When the gallery is involved in a nonprofit cultural event, television and radio coverage in the form of public service announcements may be available to you. PSAs reach a large audience and can greatly expand public recognition of your community service. Some television stations have community access departments where they will even help you produce a PSA that will be aired by the station.

Public Service Announcement

PRESS RELEASE

William Hill Gallery

5092 Wilshire Boulevard, Los Angeles, CA 90070 ▪ 310-657-1111

Contact: Peter Morton
(310) 657-1111

FOR IMMEDIATE RELEASE

CELEBRITY AUCTION AIDS AIDS

Hollywood celebrity and art collector Mortimer Mendelsohn will be auctioneer at the tenth annual fund-raising auction at the William Hill Gallery on Saturday evening, August 27.

This festive evening of music, refreshments and bidding will be uncorked at 7 P.M. with cocktails, creative hors d'oeuvre and a silent auction. Live bidding will start at 8 P.M.

The auction will feature more than 600 fine paintings, drawings, lithographs and sculptures by locally and nationally acclaimed artists, including: Earl Minkowitz, Atsuko Naru, Stephen Marvin, Pablo Gonzales, Donald Milembe, and Scott Murray.

Other items to be auctioned have been donated by local business establishments. These include dinners at three of Los Angeles' most exclusive restaurants, a weekend for two at the Hotel Rennais in New York, theater tickets, wearable art and several cases of vintage wine. Proceeds from the auction will be given to the Los Angeles AIDS SCOPE Program.

Auction catalogs will be available at the gallery after August 15. Call (310) 657-1111 for catalogs and further information

#

Note to Editors: Mortimer Mendelsohn is available for press interviews.

The Ins and Outs of Electronic Media Exposure

Volumes could be written on the fine points of gaining broadcast coverage, but here are a few basic suggestions.

Every city has some local television and radio stations that offer publicity opportunities through:

- Panel shows
- Talk shows
- Public affairs programs
- Cultural and news magazine shows

When you have an event that is truly newsworthy—a major installation, a famous personality at an opening, a fire or theft—go after electronic coverage. An example of a promising item might be an eighty-six-year-old artist (human interest), who was once a political prisoner in China (tie-in with timely news interest), and who is going to demonstrate ancient plaster casting techniques (hands-on art technique and visual possibilities for television).

Also consider the informational interview in which you discuss a topic of interest to the program's audience. For example, after a stock market plunge, you might offer to speak on "Is Art a Good Investment?" Or when a big international crafts exhibition coincides with a related show in your gallery, you might offer to grapple with the question, "What Is Art and What Is Craft?"

A word of caution: Remember that news people get irritated if you contact them about events that aren't newsworthy or ideas that are not appropriate for their audiences. Only occasionally will an exhibition hold interest for the electronic media. But when it does, seize the opportunity. Although it may be only once or twice a year, this exposure, supported by the rest of your publicity campaign, will make a significant impact.

Doing Your Homework

When you have something that you think will definitely interest the electronic media, make sure you know every outlet on your media list, what kinds of items they use, and what format their shows have. Programs never change their formats to accommodate guests, so you have to research what they do and don't do.

The way to do this research is either to watch the programs in question or to contact a PR professional for a one-hour electronic media consultation. If you have a specific idea, you can call the news planning

desk of the station. Describe briefly what you have to offer and ask them what you should do next. Ask what other shows might be interested. (Note that each show is developed by a separate staff and needs to be contacted separately.)

In researching a show, keep an eye out for an appropriate place you might fit in. Is there a certain type of story or angle they like, such as success stories, the do-it-yourself approach, interesting new businesses, consumer tips, or guests talking about their favorite community project?

Making Contact

When you are trying to get coverage of an upcoming exhibition or event on a magazine-format or talk show, allow two to three months' lead time. But be prepared to appear on short notice. Guests do cancel, and perhaps your artist or you will be called as a replacement. Outline for yourself just exactly what you want to present, and then call the assistant producer of the show and ask, "Who should I talk to about pitching a story?" Talk to the person briefly and follow up with a letter referring to the phone call, together with an electronic media press kit. (See chapter 11 for the form and packaging of the kit.) The letter should be short. It will be effective if it includes one of the following near the opening:

"This should interest your viewers because—"
"It is well-suited to television (or radio) because—"

Dear (assignment editor, TV station):

All the pieces in this Planqueley exhibition move in some way, and I think only television can do the exhibit justice. We're having a small preview on Wednesday from 5 to 7, when you would also have a chance to get some spectator reaction and interaction with the pieces. Planqueley's museum exhibition here last April was the high-light of the spring season. Attendance was the highest recorded for any living artist's exhibition.

Please give me a call if I can be of any help.

Mention a key time to cover the event—e.g., when the artist, a colorful and articulate spokesperson, will be in town, or on opening night, when visitors to the exhibition will be interacting with the pieces.

Other items to include in your electronic media press kit:

- General press release on the exhibition or event—the same one you prepared for print media (see chapter 7)

- Background press release (see chapter 9)
- Photograph (for television)
- Sample of previous tape (TV or radio) to demonstrate that you don't have green horns and a furry face and that you are articulate and respond well to questions
- Clippings of print publicity, either to establish your credibility as an authority or to establish previous media interest in the topic
- Your business card

You can follow up with a telephone call in a week or two to verify that your contact has received the media package. Again, be prepared for your contact not to remember the release or your original telephone call.

Reminder Notice: A Media Advisory

Plan to send out a media reminder notice to arrive on the day before the event. Either mail it three days prior to the event, or fax a notice the day before.

The contents of such a media advisory should include:

- Headline
- Statement of who, what, where, when, why, how
- Availability of media opportunities, such as special photo sessions or an artist interview, and scheduled times for these media opportunities

The Test Call

If a program producer is interested in interviewing you, she or he may phone you to find out exactly what should be covered and to gauge how well you would do, so be cooperative and informative. The brief outline you prepared when you first called the assistant producer to pitch the story will give you a solid information base when this call comes in. Keep in mind that the producer will be testing you not only on how knowledgeable you are, but also on whether you are quick, humorous, and frank, or vague and long-winded.

The Interview

Most veteran talk show hosts are in agreement on what qualities their guests should have. They need guests who can think on their feet, who can ad lib in a relaxed manner, who are knowledgeable enough to answer any question on their topic, and who can field any off-the-wall

questions that might come up. Ideally, the guest will have thought about the topic in terms of what would be interesting to a listener and will have all sorts of fascinating insights and a fund of anecdotes.

Other advice for those about to take part in a television or radio interview is mostly just common sense: Get a good night's sleep so you can be alert, avoid answering questions outside your field of experience, and concentrate on communicating with the audience rather than worrying about the mics or the cameras.

It's a good idea (and routine among those who make frequent public appearances) to stage a practice interview. Write up a list of questions, including tough ones that might come up and have someone interview you or practice in front of a mirror.

If you are having an artist do a demonstration, call in advance to plan the segment and to check the producer's expectations. Clarify what you are providing and what the studio is providing. Ask that a copy of the tape be made for you following the interview. Try to anticipate anything that might go wrong and come prepared.

If you are well prepared and well rested, you may find your adventures with the electronic media very heady stuff.

7

CREATING AND USING A WEB PRESENCE FOR PUBLICITY

The artworld professional can no longer ignore the Internet revolution. Most larger galleries and museums have already conceded that a business Web site is a crucial tool for conducting a proper public relations campaign and have invested the time and money required to create one. The best of these galleries and museums also know that even after their Web site is up and running, a successful Web presence requires the ongoing maintenance and updating of their Web site as well as the publicizing of those updates.

Some smaller galleries and many artists have yet to create their own professional Web site. If you fall in this category, you may need convincing that a Web site is necessary at all. Perhaps you are concentrating on a real (non-virtual) world publicity campaign and feel that a having a Web site will only duplicate your efforts. Perhaps you are a bit of a Luddite or a technophobe and have avoided getting a Web site because you are uncomfortable or overwhelmed by the technology. Or perhaps you have other more practical concerns such as the cost of a Web site.

Whatever your concerns, I hope to convince you that creating and maintaining a professional Web site is a practical investment on future financial returns, easier to create and maintain than you may think, and a necessary part of your overall PR effort, one that your techno-savvy audience now has come to expect. Having a compelling and dynamic Web presence will not replace the need for traditional public relations efforts; rather, the two methods work together to create a multifaceted,

integrated publicity campaign that, if conducted properly, will prove especially effective in reaching your audience, building your reputation, and delivering financial rewards.

ARTIST TIP: Many artists who are represented by a gallery feel that they don't need their own Web site if their gallery has one. While your inclusion on a gallery's Web site is useful to your public relations efforts, you usually don't have total control over the content, presentation, or maintenance of that site. And many financially successful artists are represented by a number of different galleries in different geographic locations. Having your own professional Web site creates a centralized place for interested press and collectors to find everything they want to know about you and your work. You control what is posted on your site and you don't need to go through an intermediary before making changes or updates. Of course your site should link to the gallery or galleries that represent you and any museums or other venues that have acquired your pieces. And you can request that the gallery or galleries that represent you link to your Web site, creating a quick on-ramp for traffic to your site.

Why You Need a Web Site

If you still need to be convinced that having your own Web site is necessary, let me remind you of the many innovations it can bring to your publicity efforts. First, having a Web site opens you up to a potentially global audience. Second, the online world is democratic, not paternal; the viewer seeks and finds what the viewer wants to see, rather than being told what they *should* want to see by the media or the government. With a Web site, your access to your public—including future collectors and clients—is no longer controlled by the media. Ideally you should use your Web site to reach the public *in conjunction* with traditional PR methods of working with the print and broadcast media. However, you may find the need to create your own Web publicity if you are not yet attracting sufficient interest from the established media. You don't have to wait for the media to publish a piece on you and your gallery, nor do you have to sweat over whether a review of your exhibits in the media will be positive. By creating your own Web site, you take control of your coverage; you serve as your own editor in choosing what to publicize. You enable the visitor to your Web site to respond to your work intuitively, rather than by parroting the local art reviewer's take on its value or significance.

Whether they find your Web site themselves or you contact them and refer them to your Web site, media contacts and interested members of the public can learn a great deal about your gallery and your artists from your Web site, depending on what you choose to post. You can include digital photographs of each artist's work and one of the artist, an artist's biography and exhibition résumé, an archive of press releases and an online version of your press kit, directions to your gallery, information about your latest exhibition, and information on how to contact you directly through the mail, e-mail, or on the phone. Members of the media, especially, tend to be frantic about deadlines and overworked, so the 24/7, always-open-for-business nature of the Internet can be particularly helpful by allowing them to get information about your gallery and exhibits when they want to, rather than depending on when you or a gallery representative might be reachable by phone or waiting for information from you to arrive in the mail. And the easier it is to get information about you to the media on the media's terms, the more likely it is that you will receive media coverage that is both voluminous and positive in tone.

You can include a virtual tour of your gallery as a whole or of a particular exhibit on your Web site. This kind of tour can be particularly useful for showing off non-frameable, three-dimensional work such as sculpture and installations, as these works are hard to capture in a digital photograph. If a piece includes an element of audio art, you can offer a sample of the sounds directly on your Web site. If your latest exhibit is a solo show, consider capturing a video of the artist being interviewed about the pieces in the show and posting it on your site.

There are even more reasons why a Web site is a necessary publicity tool for artworld professionals. Having a Web site can help save paper, prevent waste, and save money. E-mails can replace some paper letters, and directing the inquiring media to your pressroom can sometimes prevent the expense of sending out a paper press kit. Collectors can investigate the reputation of your gallery and the credentials of key staff before they come in to the gallery, or after a positive visit as reinforcement. When you have a Web site, you don't need to give the full sales pitch to every person who inquires about your gallery or an artist's work (unless of course you want to)—you can just refer them to your Web site for general information and field only more complex questions in person.

Finally, you need a Web site because these days people expect you to have one. Without a Web site, you run the risk of being perceived (fairly or not) as being old-fashioned, behind the curve, and out of touch. In a Web-oriented world, you need a Web site for you and your gallery to be taken seriously as a "brand," a player of note in the artworld.

Perhaps you already have a professional Web site and don't need any convincing of its necessity to your gallery. If you have a Web site, here are a few hints as to how to best use it to your advantage.

Create a Pressroom on Your Web Site

Museums in particular have led the way in creating "pressrooms" on their Web sites. See, for example, the San Francisco Museum of Modern Art pressroom, found at *www.sfmoma.org/press*. The SFMOMA pressroom has a home page with the following links:

- Advanced Exhibition Schedule
- Current and Upcoming Exhibitions
- Recent Announcements
- SFMOMA General Info
- Archive
- Join Press List
- Contact Us

Each exhibit and event listed has links to the corresponding press releases and images for the press to use.

"Constructing" a pressroom makes sense for the Web site of most galleries as well. The pressroom is a compilation of all of your media coverage plus current press releases and archived past releases for each exhibition or gallery event. Essentially all this involves is creating a distinct page or group of pages within your site titled "Pressroom," where you should include links to your press release and news clipping archive, your artist biographies and résumés, an artist photo, collector or patron testimonials, contact information, and an advance exhibition schedule. The advance exhibition schedule (AES) should clearly list all planned exhibitions, special events of the gallery, and director activities as well as special events by artists such as tours, residencies, workshops, lectures, commissions, and any other upcoming professional highlights, along with the corresponding dates, times, and locations. The AES is particularly useful for members of the media who are trying to plan future features that will correspond with or preview exhibits or other happenings of interest to their audience.

If certain collectors, artists, or curators have agreed to act as media sources for an exhibition or event, include their contact information (probably e-mail address only) and note that they are available for interviews. If you have digital photographs that might be particularly well suited for reproduction in print, add these to your Web site and state that high resolution (high quality) copies are available to members of the media upon request. Your contact information should also be

prominently featured. Finally, you should include a well-labeled link to your pressroom on the home page of your site. A pressroom creates a one-stop shop for members of the media who are seeking background information on the gallery or its offerings. It also provides them a potential shortcut—under pressure, they may choose to cut and paste directly from your online press releases into their own publishable copy.

ARTIST TIP: While you will still need to develop and maintain a media and contact list, with a Web site you don't need to proactively identify *everyone* who may be interested in your work (a near impossible task). Niche interests thrive on the Internet. While you may not yet know about the art-obsessed, wealthy Bronwyn sisters who live in Des Moines and have an insatiable craving for art just like the work you produce, they can search for art that fits their interests and find your Web site themselves through a search engine listing. In other words, potential clients, collectors, reviewers, and media contacts can actively seek you out instead of the other way around.

ARTIST TIP: Previously, emerging artists were limited by their finances to publicizing themselves only within a limited geographic area. Suddenly, through a Web site, reaching a national and international audience costs no more than reaching a local audience. Also, if you can identify subject matter in your art by using keywords, curators or art consultants looking for a specific genre like, "outsider art" or "landscapes" will find you on their own. For further information on the strategic use of keywords, see page 85 in the next chapter.

The Role of Educational Material on Your Web Site

Your Web site is also a great place to publish articles that you have written on art-related subjects. You should try to submit these articles to the traditional print media sources for publication, but whether or not they are accepted, you can serve as your own publisher. Consider articles on the latest art movement, techniques, or materials, current issues in the artworld, how to tell quality in art, or the difference between photographic or graphic techniques. By writing informational articles, you establish yourself as an expert, someone that collectors can trust and seek out for advice. These articles will help establish your site as educational, which may lead to your getting free listings with the Web

directories as discussed in chapter 8. They can also increase traffic to your Web site, resulting in further exposure for your gallery.

Selling Directly from Your Web Site

When you are ready, you can set up your Web site to process orders directly so that it becomes a mini-gallery selling posters, catalogs, and books on art. Some more commercial galleries that cater to tourism sell licensed items, like coffee mugs, greeting cards, T-shirts, mouse pads, key rings, calendars, and so on, all emblazoned with images from their artist's work. You will need to make a section of your site encrypted to ensure the security of your customers' personal and financial information, such as home addresses and credit card numbers. Web designers routinely help clients create successful online stores, and there are software and instructional Web sites available to assist you in setting one up yourself. However, you may find this task a bit daunting if you are a novice Web site creator and host. Consider waiting to set up your online store until you feel fully comfortable with the design of your Web site and have no trouble updating your site yourself. When you are ready, consider hiring a Web professional to set up your online store since there are a number of potential pitfalls. And before you do, make sure that you have both the product to sell and the time and commitment to respond to sales requests, as you can alienate potential customers with slow and unprofessional service.

Hardware and Software Needed to Launch You Into the Digital Age

Hardware:
- PC or Mac with a CD burner
- Scanner for scanning text, photographic prints, and slides into digital form
- Digital camera for taking pictures of art that can be posted on your Web site and for archiving
- Printer with photo quality capability

Software:
- Web site builder software (you don't need to know HTML anymore)
 - Current examples are Dreamweaver, FrontPage
 - Or hire a Web designer, if your finances permit
- Image editing software—Photoshop, Adobe PDF (if your recipients can't access your attachments or have different word processing software)

- E-mail programs for communicating
- Contact management software—Outlook Contacts works for smaller operations; PressFile (adapted from FileMaker Pro for PR), which is used by many museums and galleries; Marketing Artist (*www.marketingartist.com*)
- Scheduling software—such as Outlook
- Presentation software—such as PowerPoint

Using Digital Images

If you want to display your work on your Web site or store photographs on your computer, you will need to know how to work with digital images. Until recently, artists and galleries presented photographs of their work in slide or print form. Now art is nearly always documented, archived, and presented using digital images. The prices of digital cameras and scanners have dropped considerably in recent years and should continue to do so as more and more people go digital. And remember you can convert photographs and slides to digital format even if they were not originally taken with a digital camera, by scanning the prints or slides yourself. You can also take the conventional film negatives or prints to a camera store or photo-processing booth to have them convert the images into digital format.

> **GALLERY/ARTIST TIP:** Slides and transparencies have a short shelf life of ten to twenty years, depending on how well they are stored. A CD has a one-hundred-year shelf life. It's important that galleries encourage their artists to store their photographs digitally so that work doesn't have to be re-photographed for retrospectives. This is often prohibitively expensive once things are sold, and the artist usually will have to pay for it.

Format of Digital Images

You should keep both high- and low-resolution versions of each photograph in your archive. The degree of resolution in a digital image determines how many pixels, or tiny squares that make up a digital image, will be visible. The more pixels, or dpi (dots per inch), in an image, the sharper the detail. For presentation and reproduction purposes, you should always use the highest resolution image available, as this will yield the highest quality image. You can't successfully enlarge a low-resolution digital image; it will appear distorted. But you can shrink a high-resolution image as needed without compromising image quality.

Digital images are usually saved with a .jpg file extension, and some-times with .tif or .bmp file extensions. Each graphic file extension will save an image at a different file compression level. File compression is a process by which the computer attempts to reduce the file size of a graphic image by looking for recurrences. For example, in a photograph of a red brick house, an uncompressed file would include the location of all the pixels in all of the many red bricks, resulting in a large file size for that image. For a compressed image file of the same house, the com-puter might attempt to restrict file size by noting in shorthand the rep-etition of the many rows of red bricks, resulting in a smaller file size but potentially losing some image quality.

Security for Digital Images

For security purposes, very low-resolution images are useful. Low-resolution images of seventy-two dpi are appropriate for posting on the Web, or pasting into e-mails or press releases. This way the press and other recipients can see a representation of the image, but they cannot reproduce it with any quality. This keeps you in control of the use of the digital images of your art and helps prevent copyright infringement. In order for the press or others to obtain a high-resolution reproducible photograph, they will need to request it from you directly. Also you can embed a watermark in the low-resolution photo-graph, so that if anyone tries to reproduce it without your authoriza-tion, the watermark will obscure the image and prevent successful copying of the image. It is always a good idea to add a copyright symbol on the low-resolution copy of the digital image. This will remind the viewer that you are the copyright holder of the image and that unauthorized reproduction of that image is not permitted. Will these techniques prevent all theft of your digital images? No, but you can make sure that the quality of the images that are available to steal will be quite disappointing.

High-resolution images (300 dpi and up) should be saved on your computer for your archives and for e-mailing to photo editors who have requested it (you can also mail them a CD). Don't post downloadable, high-resolution images on your Web site, as you will have no control over who copies these images and how they will be used in the future.

Storage of Digital Images

Images should be stored in digital format for long-term archiving because they will not lose image quality due to sun and atmospheric damage like older film prints. If you have sufficient room, keep an archive of your dig-ital images on your computer. However, as digital images can take up a lot of computer storage, you may want to store some of them on CDs. Most

computers of recent vintage now have the capability to "burn" CDs—that is, copy files from your computer's hard drive onto a CD—just as they have long been able to do with "floppy" disks.

Blank, recordable CDs are cheap and easy to find at office supply stores. Just make sure to label your CDs accurately and consistently, as they are easy to mix up and misplace. Most word processing programs can be set to print CD labels, which you can then peel off and stick to each CD.

You will also need to save the photo caption text with the digital image; usually in a separate text file. Name the two files in such a way that it is obvious that they are associated with each other, such as "India Series I.jpeg" and "India series I caption.txt". Whenever you post or send the digital image, the caption text should accompany it.

There are innumerable options when saving and sending digital files. When a photo editor requests a digital image from you, ask the photo editor what digital file format (.jpg, .bmp, .tif?), resolution (how many dpi?), and delivery method (mailed CDs, attached to an e-mail, or uploaded to a Web site) she prefers for this and future photographs. You may still occasionally encounter photo editors who can't handle digital images at all and who prefer mailed prints, but they are a dying breed. Record the photo editor's preferences in your media contact database, and make sure to consult each contact's entry before sending out the next digital image.

You can combine digital photos and text into a PowerPoint presentation. If a museum, or corporate or private collector wants to see a whole series of pieces or survey the work of several artists but can't visit your gallery or the artists' studio personally, you can bring a dynamic tour of the work directly to them. You can project the presentation for larger audiences or show it to a small group on a laptop computer.

ARTIST/GALLERY TIP: Taking Great Digital Photos of Art
- Many of the tips for taking digital photos of art are the same as for film cameras:
 - Use a neutral background.
 - Mount your camera on a tripod to keep it stable.
 - Photograph frameable art before it is framed (this keeps the focus on the work not the framing job).
- If you aren't a great photographer, hire one. He or she should be well versed in digital photography.
- Take multiple photographs of each piece from slightly different angles and lighting so that you can pick the one that looks the best. Include both high- and low-resolution photographs of each piece as well. Experiment with saving the images with different graphic formats to determine what level of file compression vs. image quality produces the images you are seeking.

- For some intricate pieces, you may also want to take detail photographs in addition to photographs of the work in its entirety.
- Take both black-and-white images and color images of each piece and keep the best of each.
- For black-and-white photos especially, make sure you have enough contrast. These photographs will be useful for reproduction in newsprint or on photocopied press releases for mailing. One way to test how your black-and-white photos would look in newsprint is to photocopy the print.
- For sculpture, you might want to include multiple views of the piece from different vantage points or consider taking a digital video tour of your installation.
- Use your photo-editing software to modify the images as needed by cropping or heightening contrast, for example.
- Don't forget to photograph every piece of work before it leaves your hands—even pieces that have been sold and acquisitioned must be documented for archival and promotional purposes.

A Look at Two Galleries and an Artist's Web Site

Home Page of Gallery Web Site
www.marcosassone.com

MARCO SASSONE

home | artwork | resume | publications | schedule of exhibitions | links | notices | contact us

WELCOME
to the Marco Sassone
website

Home Page of Gallery Web Site
www.cowlesgallery.com

Charles Cowles Gallery

537 West 24th Street
New York, NY 10011

tel: 212.741.8999
fax: 212.741.6222

info@cowlesgallery.com

Current News Artists Schedule Press Releases Catalogues
Information

Home Page of Artist Web Site
www.borofsky.com

Borofsky.com

Public Sculpture	CBS Video
Installations	Numbers
Music	Individual Works
Dreams	Interview
Drawings	Résumé

jonathan@borofsky.com

Updating Your Web Site

Keeping your Web site fresh and viable is an ongoing process. If you simply create your Web site and fail to update it frequently, it will not continue to reap publicity rewards. The administrators of other sites will remove links to stagnant sites. Visitors will remove you from their "favorites" lists. To keep up traffic and the number of hits on your Web site, you must add new material to your Web site on a regular basis and let people know about the changes. Updates could include posting a new article you have written, new links to art sites that you like, digital photos of your latest exhibitions, or your latest press releases.

When you do update your Web site, you notify select contacts about the changes via e-mail. But don't put the full text of the announcements or articles in the text of the e-mail. Tease them with an enticing headline and include a link to your Web site so that the recipients can take a look at the new content themselves.

Evaluate carefully who should receive these e-mail updates. Your media contacts will be interested in major announcements and current exhibitions, but might be unresponsive to less momentous news. But former clients, colleagues, curators, gallery partners, and potential clients who have proactively sought information about your gallery may be interested in hearing about all of your news and Web site updates. For these contacts, consider sending out a summary of Web site updates (and actually updating your site with new material) on a regular basis, such as once a month or bimonthly. Consider defining your update e-mails as a "newsletter" with a recurring graphic logo and title at the top of each one, so your recipients will expect to keep receiving them and look forward to the next one.

Use the blind copy function ("BCC") available in most e-mail programs when sending out your mass e-mails or newsletters; this way your recipients don't have to worry about their e-mail addresses being sent to people they don't know. Do invite your recipients to send you the e-mail addresses of other people who might be interested in receiving your newsletter. Also, include an option for your contacts to opt out of your mailing list if they no longer want to receive your e-mail newsletter.

Use your Web site for breaking news or a gallery crisis such as a fire or theft. It is a great way to keep the media and your public informed of your message. For example:

- You contract to represent a new artist who has significant name recognition, or have been entrusted with a famous artist's estate

- A piece in a new exhibit is condemned as a scandalous/obscene/morally reprehensible/insensitive, and that condemnation is countered with outraged cries of censorship

If you don't get your message out quickly in situations such as these, someone else will define the debate. Your Web site allows you to post a response as soon as it is drafted.

Don't Forget Your Virtual Presence on Web Sites Other Than Your Own

As discussed further in the next chapter, you should work to develop links to your Web site to increase the ways your audience might find your site. Consider requesting your local arts coalition Web site to add a link to your site. Also look for opportunities for links on tourism Web sites that tout the cultural scene in your area. Groups of artists or artists in a particular region often band together to support an artist portal Web site that links to the individual artist's Web site. An excellent example of an artist portal Web site is *http://glasstire.com*, titled Texas Visual Art Online. Galleries have similar portal Web sites such as the "Galleries" page of *www.artnet.com*. The convention bureau of your nearest large metropolitan area may also welcome links to galleries in their area.

ARTIST TIP: Post press releases on your Web site to announce corporate commissions, acquisitions by museums, corporations or private collections, shows or participations in shows at galleries, museums, and alternative venues, awards, grants and residencies, lectures and workshops given.

The following page gives an example of an artist's e-mail newsletter. Keep it short and sweet.

Artist Web Site Update E-mail

Dear Clients and Friends of Libby Walker Davidson and Starflower Studio,

February has been a busy month for Starflower Studio. I was commissioned to do a mural for Dr. Dan Beisiegel's new office space in Colchester, Vermont. Visit my Web site to view a video tour of my last completed mural.

Check your mail for an invitation to the opening of my next solo exhibition; it should be arriving in your mailbox any day. This exhibition includes my latest pen-and-ink drawings and watercolor landscapes of the natural Vermont through the seasons. I hope to see you there.

Finally, I now am offering greeting cards featuring some of my most popular pen-and-ink images of rural Vermont. The cards are available from the online store on my Web site.

Please visit my Web site to learn more and to see photographs of my latest work. *www.starflowerstudio.com*

P.S. If you know anyone who might enjoy receiving these e-mail updates, send me their e-mail addresses and I will forward the latest update to them.

P.P.S. If for any reason you would like to stop receiving these occasional updates, please e-mail me and I will promptly remove you from my mailing list.

ARTIST TIP: One great way for individual artists to keep their site fresh when announcements may be sporadic is to keep an artblog, an online diary of your creative process with regular entries. For an example of an artist's artblog, take a look at this site: Itinerant Artist Project (*www.jimmott.com/index.html*). This site is also a good example of an artist *creating* a "happening" to attract media and collector attention. Also try *http://pretty-serendipities.blogspot.com.*

8

USING THE WORLD WIDE WEB AS A PUBLICITY TOOL

Whether or not your gallery has a Web site (see chapter 7 on how to develop one), you can use the Internet to create and discover publicity opportunities. You can use search engines to find information about everything from media contact information and audience demographics to trends in auction prices to staying informed about particular artists or art movements of interest. You can use e-mail to communicate with established contacts and to seek out new ones both locally and internationally.

Using the Web as a Research Tool— Learning What's Out There

Virtually any information you need to conduct your public relations campaign can be found on the Web. You can keep up on the latest in the artworld without subscribing to multiple art magazines or spending hours in the library. You can learn about buying trends among collectors, the going prices of different kinds of art at auctions, and the acquisition policies of museums. You can read up on the background of artists and other cultural figures. You can locate contact information for many people whose interest you want to cultivate, including members of the media. You can learn about emerging artists, new techniques, and use of media.

Also, you can generally keep informed about how others are participating in and regarding the work you are doing, as a kind of informal evaluation or feedback process on your PR efforts. Are you or your clients causing a stir or a buzz in the artworld? A survey of the Web will

tell you who is talking about whom. If your name is not yet circulating with regularity and generating positive responses, you just know that you have more PR work to do.

> **ARTIST TIP:** You can search for juried competitions, exhibition venues, residencies, and artist colonies using search engines and the Web. Information that once required a research librarian's help to locate can now be found quite easily and quickly.

Compiling a Media Database— Research Online Versions of Media Lists

I previously discussed in chapter 4 how to compile a database of contacts from the media and elsewhere. The Internet has greatly simplified this process. A number of sites, including *www.assignmenteditor.com*, offer compiled lists of media sources with corresponding links to their Web pages for further investigation, to gather contact information, and to learn about the audience of that particular media source. This type of compilation includes information that changes very frequently, so it is well suited for the Internet, which allows easy and frequent updates, as opposed to hard-copy media directories which may already be out of date by the time they are printed.

Other sources for media research include:

- Bacon's online directories: *www.bacons.com* (under *www.bacons.com/research/researchmedia.htm*)
- Columbia Journalism Review's MediaFinder: *http://archives.cjr.org/mediafinder*
- Media Post: *www.mediapost.com*
- Media Directory: *www.mediadir.com*
- Gebbie Press Media Guide: *www.gebbieinc.com*
- Burrelle's MediaConnect: *www.burrellesluce.com*

Online Clipping Services

Just as you can consult both books and online media directories, you can use both traditional and online clipping services. While traditional clipping services specialize in tracking conventional print and magazine coverage as well as broadcast coverage (see further discussion in chapter 4), online clipping services specialize in tracking your coverage in Web publications or Internet word-of-mouth in newsgroups, listserves, bulletin boards, other Web sites and so on.

BurrellesLuce is one of the preeminent online clipping services at *www.burrellesluce.com/PressClippings*.

Search Engines

Simply having a Web site is not enough to make a public relations impact. People must be able to find your gallery on the Web. If people know your gallery's full Web address already from some prior contact, they can type it right into the address bar on their Web browser (such as Internet Explorer or Netscape Navigator) and arrive promptly at your Web site. But how do you reach the untapped audience of people who might have an interest in your gallery but who don't know you? You need to make it possible for them to find *you*.

Surfing, or following one link after another on randomly encountered Web pages, may lead some people to your site, but most people want a direct route. People can find your site most easily by using keywords in a search engine to find your site among other related sites. To make this possible, first the search engines have to know that your gallery's site exists.

How to Get Listed

The first step is to make your site known to the major search engines. Most of the automated "crawler" search engines like Google determine how high to rank a site by the number of links to that site found on the Web. Two ways to make sure these crawler search engines are aware of your site are to build up your links yourself and to submit your site directly to search engine directories, such as Yahoo! (associated with Google), Looksmart/Zeal (associated with MSN), and the nonprofit Open Directory, which are compiled and categorized by human editors. To submit your site directly to some of the Web directory sites, go to the site and provide the information the Web directory site requests, usually the URL, or Web address, of your home page and a brief description of the content of the page including identifying keywords that Web users might use to try to find your site. Ideally these keywords will also correspond with headings on your Web page. You, or whoever is designing and maintaining the site for you, will want to have metatags on your site, to make it more likely that they will turn up in searches. Metatags contain information about the information on your site; they are basically a "keyword" listing that is typically located in the HTML "head" tag of each page.

If your site is judged to be noncommercial, your submission to the search engine directories is usually free; if it is judged to be commercial, you will likely have to pay a fee to submit your site to the directories.

The more educational or informative or purely cultural information your site contains—as opposed to just serving as a site to visit to buy art—the more likely it will qualify as noncommercial. This provides an additional reason to post informative articles on subjects within your expertise on your Web site. If the Web directory sites select your Web site to add to their directory, the Web crawler search engines will likely find it and add your site to their listings.

To speed up that process, you can submit your URL directly to the crawler-based search engines like Google or AltaVista. On Google, for example, visit *www.google.com/addurl.html,* where you can enter your Web address but are not guaranteed that you will be added to the search engine or in what time frame. (If your site is not showing up on searches, you can pay Google to analyze and critique your site for you.) Check this and other crawler search engine sites for detailed instructions on how to submit your URL. Often Web designers will provide this listing service, and there are private companies that will do it for you for a fee.

Linking to Other Pages

Another way to get your site on the radar screen of the major search engines is to link your site to other relevant, high-quality, and useful sites that are related to yours and have them link to you in return. The simple way to do this is to do some searching yourself for Web sites you like that cover topics related to yours. Think specifics here—for example, if you specialize in contemporary sculpture you may want to have a link to *Sculpture* magazine; the Sculpture Center in Washington, D.C.; the National Sculpture Society; sculpture restorers, appraisers, insurers, and movers; your local Public Sculpture reserve; and lists of hotels, museums, and other regional attractions that visiting collectors to your area might find useful. Once you have found related sites that you like, contact the site owner by e-mail and ask them to visit your site and consider linking to your site in exchange for you linking your site to theirs. If you are thoughtful about your research and show genuine interest in the sites you choose to contact, you will likely have much success in this mutually beneficial linking process.

You may also encounter Web rings, which are a topically and hypertextually linked group of sites with a more formal centralized process of submitting your site for evaluation by the Web-ring moderator. If they approve your site, you can join the Web ring and all of the other included sites will link to you and you will link to them. Cities or their visitors and convention bureaus often have Web rings to promote tourism.

The more quality sites that link to yours, the more likely that the search engines will rank your site as an important one within your niche. Remember that when it comes to positioning your Web site, it is better to be a valued expert in a specific field than an inconsequential speck in a vast category.

Good Old-Fashioned Networking—Worldwide Web Style

Just like in the non-virtual world, it is also important to register in the *minds* of others in your field, once and future collectors, art critics and scholars, other gallery owners and museum administrators, public officials, arts organizations, and the general public with an interest in art. Though it can't replace meeting and greeting influential people in person, the Internet makes this kind of networking cheaper, quicker, and easier to do. In the real world, you need to attend multiple functions, conferences and openings, and chat up acquaintances and complete strangers about what you do and why they should care. On the Internet, you can promote your gallery by visiting some Web sites and, if appropriate, participating in listserves and discussion groups all from your computer. If you have limited funds or are shy about self-promotion, Internet networking is the ideal first step. Visit the Web sites of colleagues and artists doing work that you admire; e-mail the artist or gallery owner with constructive comments and inquiries about their site, while introducing yourself and inviting them to visit your Web site. Join art-related listserves, and visit and participate in topical newsgroups, chat rooms, and bulletin boards.

Newsgroups are highly categorized Internet discussion groups where you can post information, read other's postings, and comment on what you read or anything relevant to the subject of the newsgroup. Chat rooms are locations on the Web where you can discuss live, in written form, with other chat room participants. Web bulletin boards are generally places on a Web site where you can post information or comments that other visitors to that site can then read and comment on at their leisure. Listserves are subscription-based discussion groups in which the comments of the group are distributed on a regular basis to the subscribers via e-mail. The artworld has been slow to participate in these activities, but as they become more mainstream, more art-related sites will be developed. Try *http://christo.wwar.com/artsforum* for some art-related discussion groups.

It may make sense to start with listserves or discussion groups that focus on your local art scene or your area of interest. As your name becomes better known in art circles, you can expand your participation

in listserves with larger recipient lists or discussion groups that cover broader subject areas. Your online reputation can affect your real-world reputation in both good and bad ways, so make sure your postings are judicious, professional in tone, and respectful of others.

Using the Web to Communicate

Many people have grown to prefer e-mail to other traditional forms of communication because it is quick and informal, and the recipient can read and respond on his own time schedule. Getting your clients' e-mail addresses should be a top priority. You should also develop an e-mail sales and PR strategy. E-mail judiciously used can be a great way to personalize your relationship with key collectors and with new gallery clients.

For example, here are three different e-mails a gallery sent out over a six-month period to the same client.

Hi Tom,
I hope you and Betty are planning to come to Deborah K's opening. She just sent in three exquisite new pieces in that construction format that you like. She'll be doing a talk at 6:30 P.M. prior to the public opening. If you want us to reserve you a seat, let me know by e-mail or by phone.

Hi Tom,
Attached is an article on investing in prints that I thought may be of interest to you.

Hi Tom,
I am auctioneer again this year for the SF General Hospital fundraiser. If you have any pieces you'd like to donate, drop me an e-mail. Hope to see you soon.

Sending E-mails with Photo Attachments

Try to avoid sending e-mails with unsolicited attachments. Even if the attachment is a fabulous digital art photo, most Web-savvy recipients won't open it for fear that it will contain a virus. Also make sure you have cleared with the recipient ahead of time that it is OK to send your digital photos via e-mail attachments. Many recipients do not have the server space to receive high-resolution photos over e-mail. Any digital photos sent as e-mail attachments should be low resolution.

Remember that you can also upload the photos to Web sites like Ofoto, Shutterfly, Snapfish, or PhotoWorks, among others, and simply

notify the recipient that the photos are there with a link to the site. Or you can copy the digital images on a CD and send the CD to the recipient by courier or "snail mail," a.k.a. postal mail. Or if they are not yet equipped or confident enough to handle digital images, you can print the photos yourself and send them hard copy prints or slides the old-fashioned way.

Using E-mail to Distribute Your Press Releases and Announce Events and Successes

One of the most useful ways to incorporate e-mail in your PR campaign is to distribute press releases to your contacts via e-mail. The specifics of what to include in your press releases are the same as for mailed press releases as discussed in chapter 9. As with mailed press releases, you should think carefully about who should receive the e-mails and how often you should send them out. If the news you are announcing is big enough, like a major opening, some select members of the media might be interested in learning about it via e-mail if they have indicated that they are receptive to e-mail press releases. Other e-mail press releases might be more appropriately sent to people with whom you have an established personal relationship and whom you know are interested in your gallery and gallery events. Below is a sample e-mail text.

Dear Friends of the Children's Illustrated Art Gallery,

Balloons. They symbolize celebration and levity; they fill up space with contained space. They can be blown up, they can fly away; they can POP!

This month the new group exhibition of painting and sculpture, "Balloon Art: Twisted Far Beyond the Balloon Animal" opens at the gallery full of *hot air*.

Please join us for a blowing and tying panel demonstration by participating artists; *light and airy* refreshments and, of course, balloons, at the opening this Friday night at six o'clock at the gallery. Please visit our Web site, *www.childrensart.com*, for directions and event information.

We hope to see you there. It should prove to be a mind-*expanding* and *explosive* event. Our aim is that you will not come away *deflated*.

E-mail Newsletters

You may also want to establish a regularly distributed newsletter, monthly, quarterly, or biannually, depending on the volume of the news you have to announce and information to distribute. You can send the newsletter to a select group of contacts who are invested in the gallery or the artists you represent—clients, friends, family, and others who have expressed interest in more information. For galleries with a larger regional tourist business or national or international clients, e-mail newsletters are an effective way of staying in touch with seasonal clients or people living outside the fifty-mile radius of your gallery. You can educate your audience over time by highlighting an artist or current artworld issue each month. Another smart way to use the e-mail newsletter is to summarize briefly in the e-mail the new additions to your Web site, such as new press releases and posted articles, and direct them there with a link. This will assure repeated traffic to your Web site as well as keeping your gallery and artists fresh in the minds of your interested contacts.

A Few Rules of E-mail Etiquette

In casualness, e-mail tends to be a written version of verbal communication, more formal than phone conversation but much less so than conventional letter writing. Avoid being too casual or cutesy or slang-laden in your professional e-mails, but you can also err by sounding too formal and stiff. As a general rule of thumb, you don't need to start your e-mails with a "Dear So-and-So" salutation and you don't need to close it with traditional letter sign-offs, such as "Sincerely" or "Best Regards."

In e-mails to professional contacts, pay careful attention to spelling, grammar, capitalization, and punctuation, as these are the calling cards of your communication ability. When using the spell-check function on your e-mail program, don't let spell-check override your good judgment; it can introduce errors rather than correct them if you aren't vigilant. Also avoid using emoticons—such as :-) for a smiley face or ;-) to convey a knowing wink—or common e-mail or instant messaging abbreviations (such as rotfl—"rolling on the floor laughing"—or ttyl—"talk to you later") as these can read to some as unprofessional. Finally, DON'T TYPE IN ALL CAPS. This is interpreted as a loud, shouting voice and can be very annoying to read.

Why Not to Spam

If you spam people, you will generate considerable ill will for yourself. Few methods of communication in modern life have created more ire among its targets than spam—with the possible exception of telemarketing calls during dinner and misleading junk mail notices of monetary wind-

falls. Spam is unsolicited e-mail, usually to large groups of recipients who have no prior contact with the sender. Proponents of spam, who not coincidently tend to be spammers themselves, argue that spam allows recipients to learn about opportunities and products that they might not otherwise learn about. Just about everyone else feels that spam clogs your e-mail inbox and requires you to spend precious time everyday grousing about these unwanted e-mails and deleting them. Essentially spammers hope that by sending out a vast number of e-mails, a tiny fraction of the recipients might respond with interest. But all of the uninterested recipients just get mad and spread bad word-of-mouth about the spammer.

As a business owner, this creates much more negative publicity about you and your "products" than actual customer or media interest. The smart way to communicate by e-mail is to narrowly tailor your mailing list to include only those people who have shown interest or done business with you in the past, have requested more information, or whom you feel as a result of extensive research are very likely to be interested in what you have to tell them. You can always include a sentence in your group e-mail press releases or e-mail newsletters telling the recipients how to opt out of future similar communications by e-mailing you and requesting that they be taken off the contact list. If you make this offer, make sure you promptly honor all requests to opt out (as well as opt in or requests for information) from people on your contact lists.

Where Are We Headed? The Future of the Internet for Artists, Galleries, and Museums

The Internet has already revolutionized the artworld. Art has broken free of the physical boundaries of the walls of the gallery, the artist's studio, or the museum. Rather than requiring the viewers to come to the art, the viewers can now request the art to come to them by typing in a Web address or conducting an Internet search. People in remote regions, with limited finances, or with physical accessibility problems can now view contemporary art as never before in history. Before the advent of the Internet, your sphere of influence might have been contained only to your local art scene, since reaching out to a larger audience simply required too large a marketing budget. Small galleries and museums and individual artists can now bring their art to an international audience with only a small upfront investment in computer equipment and software.

Already the Web is full of art displayed online. Web-based art has emerged as a new and viable medium in its own right. Galleries and

museums can display part of their collections with digital photographs on the Web to entice visitors into their spaces. Individual artists can display their work to a vast audience and garner interest and sales of pieces from previously unknown collectors.

However, in most cases so far, online art viewing has come nowhere near replacing the experience of viewing a piece of art in person. Will it ever? That is an issue that is already hotly debated and will continue to be an evolving topic of discussion. For now, as with online books, online art is primarily a reminder of and a pointer toward art in the real world. That will likely continue to be the case for the foreseeable future until technology transforms the way a user experiences the online world. What we can be certain of is that the Internet will continue to revolutionize the world of art, as it has the worlds of business and communication, in ways that we can barely envision today.

9 PREPARING A PRESS RELEASE

Your relationship with any media professional starts with good press releases. In the next three chapters, I discuss the technical points you and your publicist need to know about writing and producing effective press releases. In chapter 12, building on this basic discussion, I cover the specific subject of preparing releases about exhibitions.

The standard press release style and format are designed to give all the information a media person needs in a straightforward, easily accessible manner that conforms to the international standards of print media journalism.

A news-oriented press release should be a concise piece emphasizing the hard facts of a story (who, what, where, when, why, how). It is usually written for a general audience, such as newspaper readers, but it may be written for a specific column and specialty interest. You need to be able to write both.

Any subject that is straightforward and timely is a good candidate for such a release—an art theft, a special event, or a new service your gallery is offering.

For example: A gallery might put together an informational press release on any of the following:

CELEBRITY TIE-PAINTING AUCTION TO BENEFIT THE
HOMELESS KICKS OFF AT THE BRACE GALLERY ON
SATURDAY NIGHT

THE WILLIAM HILL GALLERY HELPS LIBERTY SAVINGS
AND LOAN EMPLOYEES BANK ON ART

GALLERY STANDS BEHIND ITS ART—A GUARANTEE
THAT CLIENTS MAY RETURN THEIR ART ANY
TIME AFTER PURCHASE

Don't neglect the bad news. One slightly dismayed gallery owner told us that his publicist sent out a brief news release on a small fire that had damaged the back room of the gallery; more media people turned up at his galley then than had turned up for all the carefully planned activities in the years his gallery had been open.

Donald Judstone Gallery

435 West Madison Avenue, Madison WI 53705 ▪ 608-435-9873

Contact: Peter Jake
(608) 435-9873

FOR IMMEDIATE RELEASE

ART BANDIT TAKES OFF WITH TIN HORSE

MADISON—During the opening reception for sculptor Thomas Krent at the Judstone Gallery, an art thief walked out with the tin maquette for Krent's 20-foot-high steel sculpture commissioned by the Walken Art Center in Denver. The piece is scheduled to be completed December 15, 2006, in time to kick off the opening of the new museum's 20th century sculpture court.

According to Donald Judstone, director of the gallery, "No one knows the identity of the horse thief. This has never happened before, and I can't understand why someone would want to take the maquette. It has little value, compared to the other pieces on exhibit. Walken Art Center was to be given the piece after Krent installed the sculpture."

Thomas Krent exhibited his large-scale steel horses in February 1, 2005 at the Halton Museum of Art, Kansas City. Global Art News critic Michael Dunning commented in his review, "The horses have a timeless quality. For sculptures in metal they are amazingly weightless and buoyant. The shimmering glow from the metals creates a warmth and sensuousness that defies their rigidity and instead speaks to us of lyrical beauty."

Artist Thomas Krent, devastated by the news and the fact that he will have to make another maquette, has offered a $5,000 reward for any information leading to the recovery of the work. Krent can be contacted through his gallery: Donald Judstone Gallery, 435 W. Madison Ave., Madison, Wis. 53705. Phone (608) 435-9873.

#

For more information or photos, please contact Peter Jake, (608) 435-9873.

Effective News Release and the Resulting News Item

Christie's and Sotheby's have helped to make London the center of the international art market. Both these organizations run very efficient press offices. Note how the press release hands the media a human-interest news hook.

£100,000 MING JAR PREVIOUSLY USED AS A FLOWER POT TO BE SOLD AT SOTHEBY'S

A very rare Ming jar, which the owner used as a flowerpot, was discovered by a Sotheby expert when he went to value a picture in a bungalow in the West Country. The 15th-century, blue-and-white Imperial Ming jar is expected to fetch in the region of £100,000 when it comes up for sale at Sotheby's on Tuesday 15 July.

Mr. Brian Bearne, Director of Sotheby Bearne, Torquay, was asked to give advice on a picture. During his visit, one particular pot caught his eye, which he recognized as being of considerable quality. The jar was taken to London where Sotheby's Chinese ceramics expert, Mr. Julian Thompson, identified it as being an example of the great classical period of Chinese porcelain.

Only two other examples of this jar are recorded.

The value came as a complete surprise to the owner who said that she had occasionally left it outside the back door with a pot plant in it (lot 109).

Photographs Are Available Upon Request

From: Sotheby Parke Bernet & Co.
34-3 5 New Bond Street, London, IA 2AA

For further information please telephone:

Sotheby's Press Office
Tel: 01 493 8080 Extensions: 346, 347, & 206

or

Bill Simpson
Sotheby Bearne
Rainbow, Torquay, TQ2 5TC
Tel: (0803) 26277

This is how the item appeared in a leading London paper.

Daily Express: 16 July 1980

WIDOW'S FLOWER POT SOLD FOR £265,000

by John Rydon

A WEST COUNTRY widow was £265,000 richer yesterday after the sale of a five-inch jar that used to hold plants in her back garden. The porcelain jar, in blue and white with paintings of flowers and butterflies, turned out to be Chinese; a very rare 15th-century Imperial Ming.

The unnamed owner, who lives near Torquay, had no idea of its worth until a man from Sotheby's advised her to have it valued. Before the sale it had been expected to go for about £100,000. But at the auction in London yesterday the bidding quickly reached £230,000. Then the phone rang— and a mystery man calling from the Far East knocked out all rivals with a bid of £265,000.

GIFT
The widow told Sotheby's the jar had been a gift to her husband when he was in the East.

The press release and article are both reprinted from "The Public View," International Council of Museums, 1986.

Many events that happen in the natural course of gallery business may have publicity opportunities. The gallery's twenty-fifth anniversary exhibition and special events, a trade award for excellence, a valued staff person leaving to work in a museum, an important grant or commission that one of your artists receives—these all may be excellent opportunities to get your news in print.

At the very least, this kind of announcement is good for employee and artist relations. It shows you care enough to make the effort to get the news out to a broader audience.

Announcement of an Award

Tompkins Gallery

23681 May St., Medford, OR 97501 • 541-565-3345

Contact: Trish Peter
 (541) 565-3345

 FOR IMMEDIATE RELEASE

ARTIST ROBERTA BRAKEL WINS SCULPTURE COMPETITION FOR MAYBREAK CULTURAL CENTER

MEDFORD—Artist Roberta Brakel, represented by the Tompkins Gallery in Medford, has been selected as the recipient of the sculpture commission for the prestigious new Maybreak Cultural Center. The proposed six-foot-high bronze *Striding Women* will be installed at the entrance to the Opera Plaza.

According to John Beech, director of the Arts Commission, "Brakel was selected for her outstanding design and for the humanistic values her piece conveyed." Brakel competed for the commission with more than 125 artists from all over the United States. She is the first local Medford artist to be awarded a commission through the state Arts Partnership Program.

Brakel exhibits her work regularly with galleries in New York, Chicago, and Los Angeles. She was included in the 2003 Hawkins Museum's "Survey of North West Sculptors" and was the recipient of the Oregon State Fine Arts Award in 1999.

Background Press Release

The background press release is not tied directly to a news event. It is an informational release that tells something about your gallery—its unique features, its programs and services, the artists it represents, and its director.

The background release is useful as basic copy that can be tailored to suit the announcement of any special event or to accompany a news release.

It is also valuable when you are trying to set up an interview or get a feature article. By describing the gallery or its activities with the kind of emphasis you wish, it can keep an interview or a feature article on track.

Remember the importance of blowing your own horn. A release about you as director can be developed from a human-interest angle, focusing on something that will grab the readers' attention. Sometimes the smallest point may be fascinating: You were going to play baseball in the minor leagues until your Aunt Tillie took you to the Met to see the Van Gogh exhibit, and you knew from that moment that you wanted to be an art dealer.

A background release packet might include photographs. Have two good black-and-white photos taken: one studio headshot and one in the gallery with the art. Avoid the kind of shot that tries to take in the whole gallery in wide angle, because you will become dwarfed in the process. In this situation, the director is the prime point of interest; the art is just the backdrop or context.

For a discussion of press photos, see page 134.

African Arts Gallery

826 Ramwath Way, Stamford, CT 06905 ▪ 203-356-3158

Contact: Judith Marker
(203) 356-3158

FOR IMMEDIATE RELEASE

FROM AFRICA WITH LOVE

STAMFORD—The African Arts Gallery is Stamford's first gallery to handle traditional and contemporary African art exclusively. The Gallery, which opened in June 2003, has contributed to Stamford residents' awareness of the rich diversity found in traditional African art as well as in art being made in Africa today.

The African Arts Gallery is the brainchild of primitive-art historian Donald Marker and his Rhodesian-born journalist wife, Judith Cottingham-Marker. The two decided to combine their love of primitive art with an enterprise that would allow them to help their artist friends in Zimbabwe.

"We love what we are doing," Donald Marker says. "We sometimes are afraid if collectors knew how much fun we have they wouldn't take us seriously." The Markers, however, take themselves and their role very seriously. In the two years the gallery has been open, they have mounted 24 exhibitions, including "Art of the Ivory Coast," "Dogon Ancestor Figures" and one-person shows for Shona sculptors Magwanadzi and Tukomberanwa. They were responsible for raising the money to bring the traveling exhibition, "African Arts," to the Wain Museum of Fine Arts last year. Through their gallery they have sold more than $2 million worth of contemporary African art by Zimbabwe's Shona sculptors.

(more)

FROM AFRICA WITH LOVE (continued) Page 2

Named after Zimbabwe's largest tribe, Shona sculpture is less than 30 years old. The artists are influenced by the ancient spiritual beliefs of the Shona tribe, but their work is not directly linked to tribal rituals or culture. "The artists are working in a contemporary context. Their pieces are spontaneous responses to the present rather than to the past," says Donald Marker.

Since Zimbabwe gained independence in 1980, an art school has flourished on an old tobacco farm in Tengenenge. In addition to the commissions paid to the artists directly, the Markers donate 5 percent of all contemporary art sales to the school to help pay for housing and tools for the students. Judith Cottingham-Marker points out that the war devastated the art and cultural life of the country. "While we are thrilled to be living in America, I feel that, by helping to promote these extraordinary artists, we are nourishing our strong ties to Zimbabwe and helping to regenerate the art community there."

She sees their role in Stamford as providing an "African experience" to local collectors. "We bring them the best and most interesting work that is not otherwise available in the area, and because of our backgrounds, we are able to place it in a context beyond its obvious aesthetic values."

In the past 10 years, prices have soared in primitive and contemporary African art. While the Markers pride themselves in being able to assure their clients that the art they acquire is a very sound financial investment, their greatest pleasure is in building bridges of understanding. "In the end," says Judith Cottingham-Marker, "aren't all art dealers cultural ambassadors?"

#

10

WRITING A PRESS RELEASE

Publicists do not have to be talented writers to create good press releases, but they should have strong editorial skills and be able to keep the editorial standards high and the format consistent. In preparing this chapter, I relied heavily on Kate Kelly's book, *The Publicity Manual* (Visibility Enterprises), and I recommend it to you.

Often someone on the gallery staff will have a special interest in or knowledge of a particular artist's work. This person can do the research and work up the basic information for a press release, but the final product, put into standard press release format, should be handled by the individual assigned to handle your publicity. A press release worksheet can develop the information in a way that makes it easy for the publicist to prepare the final release, which should go out under his or her name.

Background Press Release Worksheet

TARGET AUDIENCE:

MEDIA:

FEATURE EDITOR:

SOURCE OF INFORMATION/CONTACT PERSON:

IDEA:

ANGLES:

1.

2.

3.

4.

5.

EDITOR'S COMMENTS:

SUMMARY HEADLINE:

The Writing Style

The writing style for gallery press releases should be the same journalistic style that you find in your local newspaper. Your publicist may want to get a copy of *The Associated Press Style Book* published by Dell.

Sentences and paragraphs should be short and the language relatively simple, neither overly promotional nor reeking of art jargon. Avoid using such adjectives as "sensual," "beautiful," "unique," "outstanding," or other descriptive words that are excessively subjective. Let the writer of the story add the superlatives.

Bad Press Release Copy

Recent major pieces by the legendary artist Tepeck have been avidly collected from coast to coast and the supply of his unique and stunning works on paper cannot meet the demand of collectors. His paintings utilize a variety of techniques and a broad range of brilliantly intuitive colors. Tepeck's work has a very special quality embodying profound strength, vitality and movement and a sublime use of color. These extraordinary paintings and works on paper are not to be missed . . .

There is a delicate balance between creating an interesting release that will pique the editor's interest and remaining objective. Editors do not respond well to subjective or effusive language. Some editors will want to run a release verbatim, but if it does not meet their standards of objective reporting, they are likely to pass it over rather than take the time to edit it or send someone out to see if the event or the exhibition is really as interesting as you say it is.

Many magazines have short articles on art exhibitions with no art critic's byline and, in these cases in particular, the copy must read objectively as if it were a news item.

Galleries often mistakenly submit releases that mimic the style of local art critics. For reviewers and critics who take their work seriously, it is insulting to be sent these overwritten releases. Art critics who are interested will review your exhibition and synthesize your basic descriptions with their personal observations in their own terminology.

The following example of overwritten press releases tries to be interpretive, co-opting the critic's role, and succeeds only in being irritating.

While John Hart's off-the-wall-on-the-wall constructions are rooted in the early 20th-century movements of Constructivism and Futurism, his iconography and materials are more personally discursive than the social Utopianism of either movement. His

loose, dreamlike, improvisational approach to combining found objects and personal icons of family photos and fragments of letters and children's toys lacks the political engagement of Modernism and speaks more of the artist's inner life, and of his concern with the conceptual withdrawal from a dialogue with the past. Early Modernism becomes an idea remembered and the viewer is forced to deal with the more fundamental complexities of the work and of the artist's idiosyncratic self-exploration.

The Correct Format for a Press Release

Your release may receive only a moment's consideration, so its presentation is critical. A journalist's most precious commodity is time. It follows that mail and phone calls will be tackled in terms of the journalist's priorities. An unprofessional release—one that is amateurish in format or confusing in content—is liable to be tossed out.

Press release format is standardized throughout the world. The following pages show in detail how to prepare a release according to these standards.

The Headline

The headline is an objective summary of the primary content of the release; it should be as succinct as possible. The headline, "FREE LECTURE BY NEW YORK ARTIST TONY DEWITT" would be preferable to the headline, "THE BRANDON GALLERY HOSTS A LECTURE BY ARTIST TONY DEWITT."

The Dateline

The dateline originally included the date, hence the name. In current usage, it is the city in which the press release originates. However, if you are a Los Angeles gallery sending out a press release on one of your artists who is presenting a conceptual performance piece in New York, the dateline is "New York." The location of the performance takes precedence over the location of your gallery.

Datelines are particularly helpful to national art magazines, which cover many different regions. The editor, seeing the dateline, can immediately forward the release to the appropriate writer out in the field.

Body of Release—The Inverted Pyramid Format

Since most of your publicity effort will be aimed at the print media, your press releases should follow the traditional format of newspaper stories, which are reported in a form known in the profession as "the

inverted pyramid." All the vital details of an event or an exhibition are at the beginning of the release, while other information is provided to the reader in descending order of importance.

This sequence provides a flexible structure that can be adapted to serve different situations and space requirements. In a small newspaper, the entire press release might run as a feature article in the arts and entertainment section, while only the first two paragraphs might be used in a monthly city magazine. Editors will clip from the bottom up, knowing that the most important information is at the top.

The Inverted Pyramid Format for a General News Release

WHO, WHAT, WHEN, WHERE, WHY, HOW
(All the essential facts)

ADDITIONAL INFORMATION
(Extra details you would like to communicate)

SECONDARY INFORMATION
(Interesting details or facts,
but not essential material)

MISCELLANEOUS INFORMATION
(Background details)

Notes on Style for Press Release

RELEASE DATE:
Type in caps. FOR IMMEDIATE RELEASE or FOR RELEASE
_____ (date when news is timely)

HEADLINE:
Type in caps. One-line headlines are preferable; two lines maximum

RELEASE TEXT:
Double space (for the convenience to the typesetter); wide margins (1½ to 2 inches) for notes

PAGE BOTTOM:
Place "(more)" in parentheses and centered at the bottom of each page that continues to another page of the release

SECOND PAGE—RELEASE TITLE:
Second page and all others should have the release title in caps in the upper left and the page number in upper right

RELEASE END:
(signifies end of release)

EDITOR NOTES:
If you are including a fact sheet, biography, or photo, add a note saying "Biography attached" or "Photos enclosed."

Tip Sheets on Auxiliary Events

Never expect one editor to pass along your release to another. If you think your release would be of interest to more than one section of the paper, you will have to submit separate copies to the editors of these sections. At the bottom of the release, in the last paragraph, mention any special events of interest to readers. A separate abbreviated release should be sent to the calendar editor announcing the exhibition, artist lecture, or special event such as a demonstration or studio tour.

By sending a separate release, you will make sure that the calendar editors also get the information about your auxiliary event, rather than leaving it up to the art critic or feature editor to make a copy for another department. This kind of communication is an abbreviated press release form called a "tip sheet."

Tip Sheet for an Events Editor

William Hill Gallery

800 N. La Cienega Boulevard, Los Angeles, CA 90070 ▪ 310-657-1111

Contact: Peter Morton

(310) 657-1111

FOR IMMEDIATE RELEASE

SLIDE LECTURE BY LARRY HERNANDEZ

Event: Larry Hernandez, whose paintings are currently on
view at the William Hill Gallery, will show slides
and discuss his recent work.

Date: September 10, 2005

Time: 8 to 9 P.M.

Location: William Hill Gallery
800 N. La Cienega Blvd.
Los Angeles, CA 90070

Hernandez paints people in a variety of imaginative situations
drawn from real life and from memories. His emphatically
personal figurative style magnifies the psychological and social
tensions implicit in human interaction.

Refreshments will be served following the lecture.

#

Photos available upon request.

Tip Sheet for a Calendar Editor

William Hill Gallery

800 N. La Cienega Blvd., Los Angeles, CA 90070 310-657-1111

Contact: Peter Morton
 (310) 657-1111

 FOR IMMEDIATE RELEASE

LARRY HERNANDEZ

An exhibition of 15 paintings and six drawings are on view through October 15th.

Location: William Hill Gallery
 800 N. La Cienega Blvd.
 Los Angeles, CA 90070

Gallery Hours: Tuesday–Saturday, 11 A.M.–6 P.M.

Hernandez paints people in a variety of imaginative situations drawn from real life and from memories. His emphatically personal figurative style magnifies the psychological and social tensions implicit in human interaction.

#

Photos available upon request.

11

PRODUCING A PRESS RELEASE

Content is the most critical part of any release, but its appearance may be the element that first attracts an editor to read the copy. An attractive, professional-looking letterhead will help make a positive first impression. Press releases are usually on white paper and printed neatly with an easily read font. They should be on one side of the paper only so that editors may cut and paste the release as they please.

Many galleries have special press release stationery, with the words "NEWS RELEASE" printed in large letters, a nice professional touch. Use your regular gallery stationery, with the added words NEWS RELEASE or PRESS INFORMATION emblazoned across the top of the paper. This says you take your press announcements seriously. The printing can be done for almost no additional expense at the time your stationery is printed. So much business and public relations is done by e-mail today, you will want to have digital format stationery as well. It should include your logo, a hyperlink to your Web site, and standardized signature lines for each staff member.

The following two pages show examples of news release stationery.

NEWS RELEASE

Gallery Name & Logo

Street Address, City, State, Zip and Phone
Web Address E-mail Address

NEWS RELEASE

Gallery Name & Logo

Street Address, City, State, Zip and Phone
Web Address E-mail Address

GALLERY NAME & LOGO

NEWS RELEASE

Street Address City, State, Zip Phone Number

Web Address E-mail Address

GALLERY NAME & LOGO

NEWS RELEASE

Street Address City, State, Zip Phone Number E-mail Address Web Address

Prepare both an e-mail version of your press release and a hard copy version to be printed out and mailed. Print each copy fresh on letterhead or have the material photocopied onto your letterhead. If you are producing five hundred or more copies, offset printing is the best and most attractive way to produce your releases.

Your release should be stapled together if it is more than one page and mailed in a printed business-sized envelope with your logo on it.

If a photo is included, put the photo and the news release into a nine-by-twelve-inch envelope. Include a piece of cardboard to protect the photo from being bent. Print "Photograph: Do Not Bend" on the face of the envelope. Don't use paper clips or staples on a photo, and never write on the back, since marks or impressions may come through. See chapter 13 for a discussion of press photographs and hard copy and digital captions.

Timely Mailing of Releases

You don't want to miss out on publicity just because a release was sent out at the wrong time. On the other hand, few publicists have the time to prepare and send timed releases every two weeks for an event or an exhibition. The answer is to prepare all your mailings at one time. Print out all your media labels, write special notes, and put the material in bundles of envelopes according to mailing deadlines—say, eight weeks, four weeks, and two weeks. Keep them in a file box with dated dividers. Some contact management software programs include scheduling and reminder features that you can use to keep on top of press release distribution deadlines. For example, you could set the program to send you a reminder e-mail on the date you need to send the exhibition release to the local newspaper calendar editor to be included in the next week's art calendar review.

12

PLANNING EXHIBITION
PUBLICITY

The secret to effective publicity is thinking and planning ahead. If you can schedule your exhibitions at least six months in advance, you will be able to get the most out of your promotion opportunities. Furthermore, by planning your exhibits ahead, you can schedule them for the most opportune time.

Time Exhibitions Carefully

At the beginning of every year, get a calendar of all the local museum shows. This will give you a sense of upcoming museum exhibitions that might in some way tie in with your exhibitions. For example, if your gallery represents a figurative painter and you are planning an exhibition of the artist's work, it would be best to schedule it during or right after the opening of a major retrospective of figurative painting to take advantage of heightened public interest. You can also obtain a calendar of important city events from the chamber of commerce, so that you can tie in any appropriate exhibitions with citywide events and avoid planning an opening or a lecture on a date that conflicts with other events.

Tremendous interest is created during and right after a major national art event, whether it is a blockbuster museum exhibition or a record-breaking sale at auction. Often a relatively minor gallery exhibition will be reviewed if some relationship exists between the major news event and the exhibition. This kind of piggybacking to maximize your publicity efforts is extremely effective, but it requires advance planning and a little research.

Ideally, a successful art exhibition publicity campaign should begin six months before the exhibition opens. This is particularly true if you are targeting national magazines, which usually work on a six-month lead time for major articles and reviews. National and regional monthly publications often run minor reviews after the exhibition has closed.

To maximize your potential publicity, send an advance exhibition schedule every quarter or every six months to art-trade and special interest publications as well as to art writers. This can be merely a one-page sheet with a short paragraph describing each exhibition.

Overview of Exhibitions

NEWS RELEASE

Tuller-Stack Gallery

8725 Melrose Avenue, Los Angeles, CA 90069 ▪ 310-669-1523

Contact: Barbara White
 (310) 669-1523

SIX MONTH EXHIBITION OVERVIEW—JANUARY–JUNE 2006

The following exhibitions are scheduled to open January–June 2006 at the Tuller-Stack Gallery. Feel free to contact us should you need more information or photographs. Please verify the information below before publishing; titles and dates are subject to change.

January 15–February 15
Robert Tetherwhite—Paintings and Prints
The sustained quality of Tetherwhite's printmaking and its crucial reciprocity with his paintings will be explored in this exhibition of more than 15 paintings and 30 prints selected from the past 10 years.

Some of the paintings in the exhibition are from the artist's private collection and represent the first time they will be available for exhibition or sale. Included in this group are early studies for the Seattle Airport Mural, and the large handmade paper and embossed prints made at the Main Springs Press in 1988. A 50-page catalog, illustrated in color, will accompany the exhibition.

March 1–April 28
New Paintings by Masami Takagawa
Many events will take place in Los Angeles during the year in honor of Celebrate Japan 2006. One of these events will be the exhibition of the paintings of renowned Japanese painter, Masami Takagawa.

Individualize Your Planning

Since each artist or exhibition may draw a particular audience, it's best to treat every presentation as unique and to individualize the publicity. Identify past, present, and potential future clients for the artist, and consider all of the different segments of the community that the exhibition might interest.

For example: If an artist's new work is based on his fascination with architecture, a focused campaign to house-and-home and interior-design magazines or to art-and-architecture critics may be appropriate.

Decide What You Want to Say

In addition to the basic art exhibition press release geared for art critics and writers, you may want to create a more specific version for a particular segment of your audience.

For example: For the ceramic-collector magazines, you might focus on the unusual technical aspects of an artist's large-scale clay sculptures or some other aspect of interest to ceramic collectors.

For each group on your list, decide if your general release will suffice, or if you have to provide tailor-made copy. This takes a little extra effort, but a lively headline or a targeted special interest slant can make the difference between a release being published or discarded. A note of caution: This approach is excellent for feature editors; it would be totally inappropriate for serious art critics or writers, whose role is to develop their own unique perspectives on the exhibition.

Planning More Than One Exhibition

If two or more artists are showing at the same time, plan the publicity for each exhibition separately and submit the information to the media in separate releases. Only when the artists are working in collaboration, or when a group or theme exhibition has been planned, should the press release be a single item.

For example: If you are showing conceptual artists from Germany, but they are not really being shown as a joint exhibition, handle them individually. If, on the other hand, two artists have influenced each other and you are showing them together to explore the synergism involved, you will want to handle them together in one release, since the unifying idea of the exhibition takes precedence over the individuality of the artists.

Publicity Planning Calendar: September–March

CALENDAR OF EVENTS	Six Month Exhibition Overview	Geoffrey Lucas (Paintings & Drawings) Jan. 20–Feb. 20	

NEWS RELEASES

| 01: Release Date | Jan. 22 | Dec. 15 | Monthlies |
| 02: Release Date | | Jan. 7 | Dailies, Weeklies |

CALENDAR LISTINGS

01: Release Date		Jan. 10	Calendar Editors Weeklies
02: Release Date		Jan. 10	Society Editors
03: Release Date		Jan. 10	Events Editors

PSAs

01: Release Date

SPECIAL INTEREST

01: Release Date

FEATURE IDEAS

| 01: Release Date | | Sept. 15 | Art Trade National |
| 02: Release Date | | Jan. 4 | *L.A. Times Lifestyle* Exclusive |

BROADCAST MEDIA

01: Release Date

PHOTOS

| 01: Release Date | | Jan. 10 | Dailies |

| Kenso Asamu (Ceramics) | | Nature Festival Fundraiser | |
| Feb. 23–March 15 | | March 20 | |

| Jan. 1 | Ceramic Art Writers | Feb. 10 | Nature Magazines |
| Jan. 1 | Art Trade National | Mar. 10 | Dailies Weeklies |

Jan. 5	Calendar Editors Monthlies and Art Now		
Feb. 10	Calendar Editors		
Feb. 10	Japanese Daily		

| | | Mar. 10 | KQED, John Hoyt Show |

| Jan. 5 | Contemporary Craft Museum Collector's Forum | Feb. 1 | Environmental Groups |

| Nov. 15 | Regional House & Home | | |
| Nov. 15 | Focus | | |

| Feb. 10 | KLTM | Mar. 10 | KQED, KFOG |

| Feb. 10 | Dailies | | |

Planning Form for Exhibition Publicity

EXHIBITION TITLE:

DATES:

OPENING PREVIEW:

SPECIAL EVENT:
Artist's walk-through, lecture, guest speaker, dinner, performance, etc.

EVENT 2:

MAJOR TIE-IN EVENT 3:

AUDIENCE:
Past collectors, peers, other galleries, special interest writers, new clients, etc.
1.
2.
3.

MEDIA:
Daily and weekly newspapers, monthly papers, art publications, wire services, specialty publications, foreign language publications, social press, freelance writers, radio and television stations, calendar editors.

TYPE OF RELEASES PLANNED	DATE
1.	
2.	
3.	
4.	
5.	

13

THE EXHIBITION PRESS RELEASE AND ANNOUNCEMENT

When an art critic visits an exhibition, the order of his final review may be entirely different from that in your press release, depending on the style of the publication and the approach of the reviewer, but your release should conform to the inverted pyramid format. (See page 128 for the format.)

The Marvelous Quote

The way to get subjective or positive comments into your exhibition release is to include attributable quotes. These can be from past reviewers, the artist, a curator, the writer of the artist's catalog, or you can even quote yourself. The goal is to write the release so that it won't appear that the newspaper or magazine is saying extraordinary things about the exhibition, which it can only do when the copy is coming out under a byline, attributed to a particular writer.

Any direct quotes from the catalog essay or other critical source should be attributed. All other writing that appears in the release should be original so that the art writer or critic can feel free to use it editorially—without fear that he or she may be plagiarizing another professional writer's work.

Interviewing the Artist

Good publicists will interview their subject extensively before writing a press release. The most newsworthy angle may surface only after a

lengthy conversation. Many galleries will simply update the artist's old releases with a description of the current work and perhaps throw in a quote from a previous review, but if you take the time to visit the studio and have a searching discussion with the artist, something will usually surface that will help clarify the work or that will give life to the release. Your visit may also suggest an idea for a feature article or other promotional strategies.

Questions regarding the work will probably come naturally as you view it and talk with the artist. Your questions should be leading:

"What does the work mean to you?"
"Were there specific seeds of inspiration for this body of work?"
"Why or why not is this work a departure from your previous work?"
"When did you first know you were going to be an artist?"
"What were the major influences on your work?"

Note that some artists were more influenced by music, science, or politics than by other artists. Understanding this can help make your final writing effort more interesting. A fact such as the artist's mother being a music teacher and music symbols appearing in the art is of interest to the public. It makes the artist a real person, someone with whom people can identify.

These personal interviews can also provide valuable information for the gallery sales staff. You might have the artist or the publicist talk about the work to the staff so that they are then prepared to talk with gallery clients about the work.

Writing an Informed Release

Your release should give feature editors or critics all the basic information they need. Usually critics will draw on their own considerable experience to interpret the artist's work, but occasionally an inexperienced critic will have to rely heavily on what appears in the release and may even quote it verbatim. Therefore, though you want to avoid subjective and interpretive jargon, the more informed and thorough your release, the more likely you are to get the kind of coverage you want.

If you think the critic just didn't get it, then the work isn't clear, the critic doesn't have an experienced eye, or the publicist didn't provide the right information.
—Elizabeth Hess, art critic for the *Village Voice*

You can help critics do their job well by giving a clear, straightforward description of the work and by placing it in political, cultural, and formal context.

For example: If the work is related to the decorative arts movement, identify the movement and describe briefly the art's place in it.

For example: If the artist made this body of work in response to the Chinese democratic movement, explain the connection of this political event to the art.

Don't assume the critic has the time to research the subject to make these crucial connections. It's the job of the publicist to do the interviews and research necessary to write an informed release. The critic's job is to respond subjectively to the art, taking whatever he wishes from the background information provided.

Some dealers, to avoid the task of preparing an informed release, will commandeer the critic and talk him or her through the show, work by work. Most critics want time to reflect on the work quietly, asking questions when they arise. It's impossible to experience the work and at the same time try to scribble notes on information that properly belongs in the press release.

Additional Background Material

In the case of performance pieces or text-based work, additional documents may need to be provided, such as a videotape or a copy of the text. In some instances, more elaborate work may need to be done to make critics receptive to the exhibition. For example, a publicist promoting an artist of animated artwork may set up a press conference and invite the actor whose voice is heard on the soundtracks of the artist's films—a news hook. Clippings and stories about rising auction prices for animated work will generally impress critics that animation today is recognized as a serious art form. The objective is to provide critics with permission to give the work their own serious reviews.

This worksheet can be used by the gallery publicist in preparing press releases for the exhibition. It guarantees the inclusion of all critical information.

Exhibition Press Release

TARGETED AUDIENCE: **MEDIA:**

CONTACT PERSON: **RELEASE DATE:**

SUMMARY HEADLINE:

FIRST PARAGRAPH:
Who, what, where, when, why, and how

SECOND PARAGRAPH:
Important descriptive information and details

THIRD PARAGRAPH:
Works of art to be discussed (key descriptive statement)

1.

2.

3.

FOURTH PARAGRAPH (OPTIONAL):
Quote by art historian, reviewer, exhibition curator, or artist
Person quoted (check spelling): Occupation:

Quote:

Source:

FIFTH PARAGRAPH:
Background facts and information

Born: Studied:

Degrees:

Main influences:

Teachers:

Interests or travels that affected work:

Awards, museum exhibitions, recognition:

Other:

SIXTH PARAGRAPH:
Notes to reader, such as special events

Event: Date:
 Time:
 Location:

Event: Date:
 Time:
 Location:

FOOTNOTES TO MEDIA PERSON:

Photos:

Interviews:

Catalog:

The Inverted Pyramid Format

(For the Text of the Exhibition Release)

FIRST PARAGRAPH All Essential Information: who, what, where, when, why, and how, if appropriate

SECOND PARAGRAPH Important Descriptive Information & Details: straightforward description of the key distinguishing elements of the works of art, subject matter theme, the artist's technique, and so on

THIRD PARAGRAPH (OPTIONAL) Highlights of the Exhibition: descriptive detail focusing on one to three of the most important works of art

FOURTH PARAGRAPH (OPTIONAL) A Quote: quote by art historian, reviewer, curator of the exhibition, artist statement

FIFTH PARAGRAPH Background Facts & Information: these should be relevant to the exhibition or the artist's career including date and place of birth, formal training, degrees received, main influences, teachers, interests that affected the work, awards, museum exhibitions, gallery affiliations

SIXTH PARAGRAPH Special Notes to Readers: such information as the date, time, and place of the artist's lecture or some other auxiliary event—it is up to the editor whether to include this information in his or her publication

NOTES Special Notes to the Media Person: such as "photos and catalog available on request"

Exhibition Press Release

William Hill Gallery

800 N. La Cienega Boulevard, Los Angeles, CA 90070 ■ 310-389-6217

Contact: Julia Gleason
 (310) 389-6217

FOR IMMEDIATE RELEASE

NEW WORKS BY LARRY HERNANDEZ AT
WILLIAM HILL GALLERY

LOS ANGELES—Ten recent paintings by New York artist Larry Hernandez will be on view at the William Hill Gallery from September 6 through October 9. Hernandez is one of the most highly regarded of the younger generation of American painters today working in an expressionist, figurative style.

The human form is the central motif in virtually all of Hernandez' work. The figures are often painted in intense colors, surrounded by popular mass media imagery. Hernandez has developed a distinctive vernacular, balancing figures within rhythmic compositions patterned with color and light.

ART NOTES recently included Hernandez among the upcoming artists critics are watching, and art historian Ron Abrams dubbed his work "some of the best, most unforgettable 'political' paintings of all time." Hernandez expresses concern with the struggle of Third World people through his strident images of poverty and oppression. The artist describes his art as a "visual anthropology," combining memories of his cultural past with images he sees around him on the crowded streets of New York.

Larry Hernandez was born in Guadalajara, Mexico, in 1953. He received a bachelor of fine arts degree from the Art Institute of Chicago in 1975 and a master's from Yale University in 1977. He presently works and lives in New York. He was the recipient of a 1980–81 National Endowment for the Arts grant.

There will be a reception for the artist on September 6 from 7P.M. to 9P.M.

#

For information and photographs, contact Julia Gleason, (310) 389-6217.

Every city has numerous opportunities for free listings of art events. In the San Francisco Bay Area, there are sixty free calendar listings available in a diverse range of media: daily, weekly, and monthly newspapers; city magazines; regional consumer magazines (such as house-and-garden journals); tourist information magazines; art guides; and special interest online calendars of events.

Most papers and publications have special editors for their Sunday calendar sections, who also may be in charge of selecting the photos that are reproduced. They may have different daily calendar editors for special events. Send your request to be listed to the appropriate calendar editor by name.

There are many more listings submitted than room to print them, so it may be helpful to establish rapport with the important calendar editors. If writing several versions of the listing to suit key media is more work than you want to do, have a standard calendar listing tip sheet available to use (see page 111). Never send your full press release and expect a calendar editor to extract the information and write a listing for you.

Photographs

Whenever you have a good photo, send it along with a photo caption, particularly to the more important calendar editors. In the reader's mind, a photo highlight carries almost as much authority as a critical review. For a full discussion of how to handle press photos, see page 134.

Timing Your Mailing

Magazine calendar editors and daily newspaper calendar editors work on different time schedules. When you send out your press information, send it on the appropriate schedule for the media you are targeting. See "General Scheduling Guidelines," page 36.

Tourist and Art Guides

If tourists to your city are important to your gallery, I strongly recommend that you list in the tourist guides not only your current exhibition, but also the other artists you represent, particularly those with the most name recognition. The same advice applies for gallery listings in art guides, such as the *Art Now Gallery Guide*. Often a gallery that is showing an emerging artist also represents many established artists who have followings among serious collectors. Collectors and visiting art

professionals use these art guides by scanning the listings for names they recognize, and they judge the caliber of the gallery by association. On calendar listings, whether they are free or paid for, always include a listing of the top artists you represent or whose work you have in inventory.

Artist Biographies and Exhibition Fact Sheets

If media people come to your gallery to review an exhibition, they may request additional information about the artist. It is customary for galleries to have a current biography and bibliography available on any artist they are exhibiting.

Sometimes a publicist will choose to include a biography with the press release—for instance, when an artist is famous abroad but not well-known in the United States. In this case, the release should still have the most important highlights of the artist's career. The biography is a supplement.

The same is true for the exhibition fact sheet, which is an additional background sheet giving more in-depth information on the exhibition. Museums and galleries that are collaborating on a show often use these to give the press information on where the show is traveling, what events are being planned, descriptive information that elaborates on the release text, and excerpts from the catalog essay or past reviews. Make sure to note their inclusion on the release by typing "See Attached Fact Sheet" in the Notes section.

Multiple Artist and Theme Exhibitions

The format for these situations is somewhat flexible, depending on whether you want to place the emphasis on the theme or on the individual participants. Following are two releases that show variations of the inverted pyramid format.

Multiple Artists Exhibition Press Release

NEWS RELEASE

Gallery Richel

2424 Pacific Boulevard, San Francisco, CA 94015 ▪ 415-546-7878

Contact: Lisa Mercer
(415) 546-7878

FOR IMMEDIATE RELEASE

(HEADLINE)

CRITICAL INFORMATION

SAN FRANCISCO—Gallery Richel will show new paintings by Marco Calmetti and Alfredo Morsone, May 12 through June 2, 2006. Calmetti and Morsone began their collaboration in 1972 while both still lived in Milan, Italy. Working as an artistic team, Calmetti photographs images and Morsone then incorporates them into a painting. Together they develop the theme of the work, each making contributions to the final composition.

OVERVIEW OF THEME

The paintings in the Gallery Richel exhibition chronicle the artists' fascination with American politics and social/cultural issues. They often juxtapose traditional European iconography with examples of American pop culture.

DESCRIPTION OF WORK

Calmetti and Morsone claim not to be dissident or political artists. They see themselves more as objective observers of the current scene. Drawing on a broad spectrum of traditions, they juxtapose modernist, conceptual elements with examples of classical realism, figurative, and narrative painting.

OPTIONAL QUOTE AND/OR BACKGROUND INFORMATION

Before Calmetti and Morsone moved to the United States in 1978, they had several successful exhibitions in New York at the Hanson-Haegler Gallery and were included in the Sharp Museum's "New Painting-Photography Exhibition" in 1975.

SPECIAL NOTES TO READER

Calmetti and Morsone will be present at the artists' reception on Wednesday, May 11, from 5:30 to 7:30 P.M. Calmetti will present a lecture on their work at the Art Institute on Friday, May 13, at 7 P.M. at the Adams Lecture Hall.

#

NOTES TO MEDIA

For more information or photographs, contact Lisa Mercer, (415) 546-7878.

Theme Exhibition Press Release

Bradon Gallery

200 Post Street, Seattle, WA 98195 506-305-2609

Contact: Steven Marvin
 (506) 305-2609

FOR IMMEDIATE RELEASE

ART FURNITURE AT BRADON GALLERY

SEATTLE—The Bradon Gallery will represent a group exhibit of artist-designed furniture during the month of May. The exhibition will include works by eight artists of international reputation: Tony Brat, Margaret Hooper, Philip Doet, Alphonse Garcia, Heinrich Gross, Tony Abbott, Kyoko Maru, and Kenso Eizen. This diverse group of contemporary furniture makers and artist designers represents the vitality of the current art-furniture design movement. — **CRITICAL INFORMATION**

The use of unconventional materials, unexpected shapes, and symbolic elements of design all contribute to breaking down the traditional boundaries between art and functional design. These new works, by their psychological presence, challenge the viewer to redefine the purpose of furniture. — **OVERVIEW OF THEME**

Garcia, Doet, and Abbott use electric colors and fantastical elements, exemplified by Philip Doet's zebra-striped dining table and Day-Glo jungle green chairs. Gross and Eizen create traditional pieces in unexpected materials, reinterpreting the past in distinctly contemporary terms. For example, Kenso Eizen's shimmering Plexiglas chair has the austere simplicity of its Shaker inspiration. Hooper, Brat, and Maru are at the opposite end of the spectrum. Their minimalist high-tech approach integrates Western and Eastern elements to create an aura of serene spirituality. — **HIGHLIGHTS OF SOME KEY WORKS**

Guest curator for the exhibit, Martin Babero, director of Seattle's Hiller Brown Museum, comments: "The extraordinary daring of these maverick artists has served to alter our preconceptions of the purpose of furniture." — **QUOTE**

Several artists in this exhibition (Abbott, Maru, Doet, and Eizen) are included in the Museum of Art's current exhibition, "New Directions: Architecture and Design," through June 16. — **BACKGROUND FACTS**

An opening reception for the artists will be Wednesday, May 16 from 5 P.M. to 7 P.M. — **NOTES TO READER**

#

A catalog for the exhibition and photographs are available on request. See attached fact sheet and artists' biographies. — **NOTES TO MEDIA**

Press Photographs

If you are enclosing a photo with your press release, note "Photo Enclosed" in the section at the bottom of the release. Many outlets today prefer digital photographs to printed photographs. For more on handling digital photographs, including how to handle digital photo captions, see pages 75–79.

When an outlet wants a printed photograph, eight-by-ten, glossy black-and-white photographs are usually preferred; some newspapers will accept a five-by-seven size. Photographs should be high in contrast, with sharp detail and a neutral background. Avoid garage doors, bushes, trees, or other distracting backgrounds. Never send slides or transparencies. If someone is interested in covering the exhibition and wants slides or color transparencies, you will be contacted. Remember, a good way to test whether a printed photo will reproduce well in the newspaper is to make a high-quality photocopy of it.

Many galleries do not send out photos with their releases; instead, they put a note to editors that photos are available. I think the decision to send a photo depends on how well the artist's work photographs. Some magazines and newspaper calendar editors will highlight an exhibition just on the merit of an excellent photo. The public reads a great deal of authority into these published photos. The message conveyed is that the exhibition is being highlighted as worthy of the reader's interest. In short, if you have digital images always send them if you are e-mailing your press release. And by all means, if your media contacts want printed photos, send photos to your priority media contacts whenever you have good ones available. You may find that your media exposure will increase significantly by this practice alone.

Press Photo Captions for Printed Photos

For printed photos, each photo should have a printed caption attached to the back, since the photo may be sent to one department for processing and the text to another. Never write on the back of a photo directly with a pen or pencil. Use adhesive labels printed on your computer; they will adhere to the back and can't get lost.

The caption should include the following: artist's name, title of the work, date of work, medium, title of exhibition, gallery name, address, phone number, and a credit to the photographer. Additionally, depending on the targeted media, you may want to include a photo caption summary headline, such as:

"DIVISIONS ON A GROUND," ONE OF 20 NEW PAINTINGS BY ALLEN COOK AT THE VIRGINIA WEISS GALLERY, 1245 Cole St., Chicago, 11–6 Tuesday–Thursday, 11–5 Saturday.

Always write your summary headline in the present tense so that it sounds current. Then repeat your standard photo credit information so the editor can choose which to use. If your photo has several objects or people in it, identify them from left to right.

If there is more than one photograph, number the photos and captions so they can easily be put together.

Format for Photo Caption Labels

William Hill Gallery
800 N. La Cienega Boulevard, Los Angeles, CA
(310) 657-1111

Summary Headline (optional):

Artist:
Title:
Date:
Medium:
Size:
Credit Line:
Exhibition:

This photograph may not be reproduced or publicly exhibited without written permission. If permission is granted, it must not be cropped, bled, altered, or printed on colored stock. If a detail is used, it must be so identified. The above credit line must accompany any reproduction of this photograph on the same or facing page.

Exhibition Press Kit

The press kit is a handy packaging device—and an important one—when you wish to do a thorough campaign. A stiff cover with two inside pockets is perhaps the best for your press kit. The cover might have a reproduction glued to it and/or the name of the sponsoring gallery. If your catalog happens to be eight-and-a-half-by-eleven inches vertical, you can do an overrun and use the covers as your kit cover.

Diagram of a Press Kit

TOP LEFT

1. Checklist for Exhibition or Copy of Catalog
2. Artist Biography
3. Artist Bibliography
4. Reprints of Reviews

TOP RIGHT

1. Optional Personal Note to Media Person
2. Exhibition Press Release
3. Press Photo and Caption
4. PSA (If Appropriate)

Business Card

Exhibition Press Kit Checklist

Your kit should contain some or all of the following:

- Press releases (a background release on your gallery, plus the special release pertaining to the exhibition)
- Tip sheet (an abbreviated press release for support events, such as artist-lecturer or walk-through; have a separate tip sheet for each event)
- Biography of the artist and bibliography
- Photo and caption
- Copies of any previous press coverage the exhibition or the artist has received
- List of special activities planned
- Any other information you feel would be helpful or of interest to the media
- Your business card stapled to the inner pocket

A personal note may be included if appropriate. This adds a friendly touch and can be valuable in helping your contact focus on some aspect of your exhibition that makes it particularly suited for her or his audience.

Exhibition Announcements

Exhibition invitations are perhaps one of the most misused, misunderstood, and undervalued communiqués in fine art public relations. Rarely do artists or exhibition sponsors take the time to define the purpose of the mailing, or decide what they want it to communicate and what results it should achieve. Too often exhibition invites are boring, generic renditions of Who, What, Where, and When. And announcements do not always have to come in four colors and have two sides.

Well-conceived announcements will generate a buzz for an exhibition, increase attendance, and promote the sponsor and/or artist long after the exhibition is over (i.e., notice how long great posters or announcements can wind up hanging in storefront windows, on refrigerators, or in office cubicles). They have great potential for educating prospective collectors or curators about your gallery's offering. An eye-catching, informative announcement that includes a brief biography can also generate press coverage, invitations, and more exhibition opportunities. They also are a great way to keep your gallery's name in front of influential people and to stay in touch with core constituencies that live outside the local attendance area of the exhibition. Think of them as mini-visual or written catalogs with either an artist's statement or brief bio included. It is best to send them in an envelope so they don't get trashed going through the mail. If possible, write a personal handwritten note on each card—something as simple as, "I hope you can join me at the opening, Sam."

ARTIST TIP: When you are creating your own announcements, print extra copies for future use. When printing two-sided announcements, have an extra five hundred or so printed one-sided (with just the photo of your work and your name sans any dated material) so they can be used for some future use, including note cards, announcements, or packets to send to art consultants and galleries.

Gallery Announcement

(Front cover content of a 5 × 7 postcard)

Artist Name

Image
(color or black-and-white)

Exhibition Title

Preview Opening Date

Gallery Name

Logo

Address and Phone

(Back cover content)

Thumbnail Photo of Artist

One of the Following:

Selected Biography

Portion of Catalog Essay

Gallery Logo and Address

14

PUBLICITY TIPS
FOR INDIVIDUAL ARTISTS

In the many years that I have been consulting with artists on their careers and doing marketing seminars for them, I have found that only about 2 percent or fewer of artists seem to enjoy marketing and public relations activities. These artists are often social people who welcome the opportunity to get out of their solitary studio environment and interact with people. Some of these artists have literally made their art careers on the backbone of their social skills.

Most other artists feel that making the work should be enough, and dread the necessity of having to launch a public relations campaign to help their careers thrive. Many artists with gallery affiliations wrongly assume they can rely on their galleries to handle PR for their career advancement. Some artists feel that self-promotion taints their work, while others have an aversion to it simply because they have not yet received media recognition. Regardless of their attitude toward self-promotion, nearly every artist agrees that their sponsor—gallery, museum, or other organization—is never doing enough on their behalf.

In the past, galleries were usually solely responsible for public relations on behalf of their artists. Today galleries are operating in a highly competitive environment where most of their public relations energy must be directed toward gaining media recognition for the gallery as a whole and for differentiating the gallery for prospective clients and artists. There is little time left for developing individual artists' careers beyond what is necessary for the success of the gallery. Sometimes, there is even a conflict of interest between a regional gallery's interest in

keeping an artist's career local and that of an artist who wants a national or international career. Sadly, artists and their dealers are not always on the same page when it comes to public relations and, to a greater extent than ever before, artists have to look after their own careers. The good news is you can be proactive and take your reputation into your own hands. Of course the bad news is you have to take the initiative.

What's Your Attitude about PR?

In my seminars, I describe the "Five Hindrances" or self-defeating attitudes that artists tend to fall into regarding their promotion campaigns.

The Seekers, Looking for an Art Angel

Instead of taking initiative, these artists are hoping for *someone else* to appear (a gallery director, a spouse, a friend) who will save them from taking responsibility for their career development. For one thing, this "art angel" may never materialize. But even if you find someone willing to help you, you are giving up control over a vital part of your career. Success in the artworld in large part comes from the connections an artist is able to make and maintain. Other artists, curators, dealers, collectors, artworld vendors, and members of the media all contribute to the warp and weft of a successful career. When you delegate responsibility for your career to someone else, you forfeit the opportunity to make many of these valuable contacts personally.

The Jugglers

These artists try every possible PR activity, whether it's right for them or not, and too often succeed at none. Jugglers read every art-marketing book they can find and implement as many strategies as they can muster, sometimes to the neglect of their artwork. They waste time implementing strategies that are not appropriate for their work, location, and the stage of their career. What works in Chelsea doesn't necessarily work in Cincinnati.

The Thinkers

These artists think about all the things they should or could be doing for their career and become so overwhelmed that they do nothing, and paralysis sets in.

ARTIST TIP: Sometimes mapping out all the possibilities visually on a large piece of paper will allow you to see the breadth of possible activities, evaluate them, select what's right for you, and prioritize those tasks.

The Procrastinators

These artists often procrastinate so long that by the time they do implement a strategy it is too late to be effective. Timing is everything in PR. Doing less at the right time is far more effective than doing more at the wrong time.

The John Wayne Types, or the Loner Attitude

"I don't need to do anything beyond the work itself. I don't need anyone to help me; the work speaks for itself." Any artist who is really successful will tell you that they could not have achieved their position without a lot of help from their network of friends and artworld contacts.

Successful artists realize that a public relations campaign is a necessary component to a successful career; they set realistic career goals and allocate a percentage of their time each week to working on self-promotion. Depending on your particular situation and the career goals that you are trying to achieve, time for marketing and PR could take from three hours a week to one full day each week. One way to allocate your time is to figure out how much total time you have each week for your career and allocate a portion, say 15 percent to 30 percent, of your time to marketing and PR activities. Be sure to schedule it in as you would studio time.

Why Seek PR?

In every artist's career, there is a direct relationship between your visibility and your sales, and other opportunities for career advancement. The baby-boomers who now make up the largest segment of art buyers are not necessarily art cognoscenti who subscribe to art magazines or even read the art criticism in their daily newspapers. They often came to their appetite for art through exposure to it in college, in mass-circulation magazines, on television, and through blockbuster cultural events publicized in mainstream media. You need to think outside of the traditional art-trade media box and seek more general cultural and human-interest exposure and media coverage.

To a layperson, a soft human interest newspaper story or a feature in their local city magazine is just as important as a great review in an art magazine, and they are far more likely to read the human-interest story or feature. PR works exponentially. A press release can lead to a feature article about you. Even mainstream coverage can lead to invitations to participate in community events, exhibitions, auctions, or speaking engagements.

Members of the media often keep topical files and store press releases to use at a later date. A release I sent out on artists and dual careers resulted in a feature article in the *Los Angeles Times* two years after it was

sent out. Likewise, PR coverage has a long shelf life. After it appears you can include the clippings in future kits for the media, galleries, museums, or collectors. Published articles or reviews can help you obtain grants, fellowships, artist residencies, even a bank loan for some needed equipment for your studio.

A Word about Seeking Art Reviews

There is no question that reviews of your art can help your career, particularly in times when so many art dealers and collectors are not very knowledgeable about art. The third party endorsement of an art critic goes a long way with individuals who are not secure about their own taste. Even mixed reviews are better than none.

Inexperienced curators are sometimes challenged when looking at art that is different and not in line with a familiar historical frame of reference. A review that helps put your work in context can be invaluable. By all means, artists producing work that might interest art critics should seriously pursue having their work reviewed. Unfortunately, many artists become obsessed with getting reviewed at the expense of many other valuable career-enhancing activities. Every artist should have a Plan B for getting media and community recognition beyond art reviews. Many artists have very successful careers without ever getting reviewed.

Moreover, many artists are making good work that will never be of interest to an art critic. It's important for you to know where your art fits in the artworld and what media coverage you should realistically expect.

Create a Personal Marketing and PR Plan

One of the biggest problems I have encountered working with artists is the "overwhelm" factor—too many opportunities and no system for prioritizing them. By creating an annual career plan, you can decide on your key goals and strategies for the year. This way you can then concentrate on implementing them, rather than becoming drained thinking about everything you *could* be doing. In the case of PR, correct timing is so critical to success that a well laid out plan will always outperform the best improvised one.

There are many books that focus solely on marketing for artists; an all-around excellent one is Caroll Michels' *How to Survive and Prosper as an Artist*. Additional sources of information about the subject can be found in appendix A of this book under "Publications." The following discussion simply gives you an overview of how to plan for PR activities as a part of your overall marketing and self-promotion campaign.

Your Year in Advance
"Timing Is Everything"

Winter

Fall Spring

Summer

ARTIST TIP: How to Make an Annual PR Plan:

1. Fill in all the milestones that you know about in advance, including exhibition dates, grant deadlines, installations, etc.
2. Fill in important personal events that are time-consuming, e.g., a two-week vacation, a trip to attend a wedding.
3. Review where you are and where you want to be. Make a list of key career goals you would like to achieve this year. See the career strategies list on pages 147–148.
4. Select the most important goals that are achievable within the next year and schedule these vital goal deadlines in around your other deadlines.
5. Work back from each main goal and develop strategies for achieving it. For each goal, break it down into a progressive series of tasks.
6. Calendar in your PR strategies or tasks so that you allow adequate time to prepare and implement them.
7. Also, once you've filled in your calendar with goals and tasks for the coming year, make sure you look at it often—ideally once a day—so you don't miss deadlines. Always look ahead and prepare for the next one.

For example: Your goal is to be accepted by a gallery for their summer "new artist introductions" program. Add the following entries to your calendar:

- Note the deadline date for applications, as well as the dates you should hear about acceptance.
- December: prepare inquiry letters for "New Introductions"
- January: mail "New Introductions" packets
- Spring: finish series of pieces for possible "New Introductions" exhibit
- June: Opening of "New Introductions"
- Once the exhibit is approved, schedule in PR activities, e.g., prepare artist statement; draft press release; have photos taken for announcements and media mailing; update mailing lists, etc.

Selected Career Strategies

- Set career goals for the year
- Choose strategies for each goal
- Add them to the calendar

Basic Career Tools

- Résumé ▪ Artist's statement
- Biography ▪ Bibliography
- Visuals ▪ Portfolio ▪ Mailing list
- Press clipping file
- Stationery ▪ Web site

Secondary Career Tools

- Color postcards ▪ Illustrated exhibition catalog
- Illustrated monograph ▪ Films, video
- Posters ▪ Brochure

Program Development

- Exhibitions, including creating your own opportunities
- Loans and commissions
- Special events/activities ▪ Slide registries
- Subsidiary art projects
- Milestones (solo exhibition, retrospective, monographs, major commission, etc.)

Direct Mail and Electronic Sites

- Promotional piece ▪ Museum mailing
- Special interest mailing
- Trade mailing

Advertising

- Web site ▪ Print and electronic media
- Trade publications

Sales Activities
- Galleries - Corporate and public sector
- Private collectors - Sales parties - Open studio events
- Special project commissions - Fairs and festivals
- Public places (restaurants, malls, airports, hospitals)
- Craft and special markets - Trade shows
- Direct mail - Renting and leasing art
- Juried shows - Contests
- E-commerce - Agents and representatives

Public Relations
- Articles you write or have written - Special events
- Art criticism - Power dinners
- Lectures/demonstrations - Information listings
- Open studio - Press conference
- Publicity stunts
- Cultural/community events
- Cooperative ventures
- Contest/awards - Auctions

Networking and Personal Marketing
- Contacts with people of influence
- Social events - Trade events
- Personal contacts with clients
- Organizations you join
- Relations with artists
- Relations with others in the art business
- Apprenticeships - Internships

Funding
- Grants - Residencies
- Fellowship

Choose Strategies Based on Your Strengths and Preferences

Most people tend to do what they like to do or what they excel at and procrastinate about the rest. When I work with artists on developing their yearly plan, I try to help them select activities that use their core strengths and interests. And if a task requires a skill they don't enjoy, such as writing or making cold calls, we develop a plan for finding the help they need. It is best to be realistic about the tasks and choose activities that you are likely to implement rather than ones that you are likely to procrastinate on or not do at all.

If you are an introvert and dislike large parties like openings, then networking at artworld events, no matter how successful it can be, may not be the right strategy for you. Some artists like to write and accomplish a lot just by writing releases and articles. Others may accomplish an equivalent reputation boost just from targeted socializing and using their network effectively.

Managing Your Campaign

Whenever possible, try to manage the PR campaigns for all your activities yourself, whether those activities are sponsored or not. Many galleries and even museums have erratic public relations departments that are often stretched to the gills, or for various reasons are lax in their duties. Some are disorganized, overcommitted, and/or lacking the knowledge of professional PR practice and how to maximize the impact of an offering. In the case of group exhibitions, the curator or PR person for the gallery may send out a general release for the whole show and maybe only highlight an artist or two that they find interesting. You and your work may not even get a specific mention, or your name may just appear in a long list of contributors.

No one is going to promote you, or know your work and its significance, better than you. Many in-house PR persons are isolated in institutions and don't get the close contact with artists that make for good PR. It is your responsibility to make contact with these people and supply them with the personal information that makes for successful PR campaign. They can only promote you with passion if they know you and your work well.

Six months out, plan the campaign, and then make an appointment to meet with the sponsor to discuss strategy. At best, see if you can assume a managerial role or at least a partnership where you are making a major contribution to the campaign. Ideally, the releases should go out on the sponsor's letterhead. If the sponsor does not do regular PR, then offer to write the materials yourself on their letterhead subject to their approval.

If you feel that the sponsor is not adequately covering the event, then you can also send out media releases on your own letterhead, but try to avoid duplications to the same media. Get the contact list your sponsor is using and fill in the gaps with your own releases. During the meeting, make the following inquiries about their mailing list:

1. How up-to-date is the list?
2. Are you targeting special interest groups?
3. What is the timing of different aspects of the campaign?
4. Do you mail to free listings, photo and event editors, as well as calendar editors?
5. How frequently do you mail announcements during longer exhibitions?
6. What kind of special programming are you planning?

Basic Tools

All artists need some of the following basic tools to launch any kind of marketing or public relations campaign.

Stationery Suite including Press Release Stationery

Your business card and stationery are often the first and only chance you have to make an impression. Sponsors want to know that they can depend on you to deliver in a timely and professional manner. Your presentation materials can either give the impression of a consummate professional or of a rank amateur. Haphazard, unprofessional-looking materials communicate that you are not serious about your work. Don't take shortcuts here; give your presentation materials the same attention to detail that you would your art.

Stationery should be pretty streamlined and business-like; over-designed stationery will sometimes get tossed. Test your design by making a photocopy of it to make sure all the essential elements are readable. Since so much business and public relations is done by e-mail today, also have a digital format, including a standardized signature line, made so that you can use it for e-mail communications. Most artists do not need a logo. If you think a logo is appropriate to the segment of the artworld you are working in, then follow the conventional wisdom about what makes for a successful presentation. Remember, museums and galleries selling museum-quality art shun artists who present themselves in an overtly commercial way. Overdone graphic logos can compete for visual attention when they appear on announcements with actual photographs of your artwork. Before committing to a design, test it in every situation it will be used. If you have established sponsors or collectors, get their opinion on the design.

Selecting a Business Name

Think very carefully about using a name other than your own. All your publicity springs from your business identity. Ultimately you want to publicize your name and reputation; if you put something between that such as "Abstract Expressions" or "the Big Picture Company," you then have to publicize two names and hope that people remember the right name when they are contacting or recommending you. Most people remember names of real people more easily than they do contrived business names. Ask yourself why you feel the need for a business name. Are you hiding behind it? Does it somehow feel easier to promote a business name than to promote yourself? In the commercial arts-and-crafts world, business names are accepted, but in the fine art world they are sometimes a red flag that you may not be a serious fine artist. In some venues, it can be very damaging to a career.

An Artist Résumé

Be sure to include a section in your résumé that highlights the public relations activities in which you participate. For collectors, sometimes these extracurricular activities are a great source of interest and a bridge to getting to know your personal side. Collectors want to be close to the creative source and seem to have endless fascination in the personal lives of artists. Often, if they are drawn to your work, or have bought several pieces, they want to see your profile as an artist on the rise.

For example: You could include a line about your community activities:

Art Auctioneer, "Rafael House, Art Auction to End Bay Area Homelessness," November 2004

Celebrity Chef, "St. Anthony Kitchen Fundraiser," January 2005

Artist's Statement

For many artists, statements about their work are the most challenging part of public relations. First and foremost, your artist statement is a bridge between you and your public and sponsors. It helps curators and gallery staff to understand your work and what motivates and inspires it. The target audience is not a museum director or art critic, but rather a layperson such as a collector. Imagine you are talking to your favorite Aunt Tillie or a college friend, trying to explain what this new work of art means to you, how you made it, and what inspired you. Be sure to include any interesting technical information, insights about symbolism, or insider information that may help your reader understand the work.

Avoid getting bogged down by writing something that sounds like an intellectual art review rather than a personal statement. If possible, your voice should come through so that the reader gets a sense of your personality. A very effective way to accomplish this is to have a friend interview you with specific questions to ask. Tape the interview and ask the interviewer to take notes about when you say something interesting and quotable. Another person will often have a different perspective about what is interesting. Artists often find the most interesting points too corny, irrelevant, obvious, or too revealing to include. Consider leaving those points in. When a publicist is doing PR for an exhibition, she is looking at artist statements for good quotations that she can attribute to you, as well as good clear descriptions of the work. She does not want something that sounds like an art critic wrote it.

Today's collector wants to be close to the creative source and to understand the creative process. Your efforts to nourish this deep hunger as well as better inform your sponsors will be rewarded in sales and by having an informed, devoted network of people capable of furthering your career and motivated to help make it happen.

Slides and Photographs of Your Art—Digital and/or CD-ROM

Most media outlets want digital photos. Some isolated places still use slides but that is changing rapidly. See the section in chapter 7 on taking good digital photos. Galleries are transitioning to digital as well. Slides and transparencies fade overtime. With the technological advances available today, artists can burn their own archival CDs or send their slides or digital images to a processing house to have one made. Some of the many benefits of CDs are their portability and their archival quality. If stored properly they will last for a hundred years or more. The images can also be transferred to a presentation program like Microsoft PowerPoint or to a page layout program that will allow you to create a brochure, poster, or announcement. You can also create a DVD multimedia show of your work and of you speaking about it, which you can use at art fairs and exhibitions and post on your Web site. A Web site can be a vital part of your PR arsenal as an artist. For more on how to set up and promote your Web site, see chapters 7 and 8.

Reprints or Digital Copies of Past Media Coverage

Reprints of past media coverage are one of the most valuable PR tools an artist can have. These clippings have a long shelf life and can be used

again and again. Too often these valuable reviews or features are thrown in a box without proper labeling so that they cannot be used later for catalog or bibliography entries. (See chapter 4 for instructions on how to correctly keep your PR records.) With so many newspapers available online it is possible to download good copies with mastheads for e-mailing to your list or posting on your Web site. Feature articles, with permission, can also be scanned into a newsletter or mailed out in press kits or releases to your core constituencies. If you are launching a big PR campaign nationally, consider subscribing to a clipping service. It may be the most effective way of capturing all your media coverage. See chapter 4 for more information.

For example: When Brian Clark received a great review for his sold-out gallery show in a resort town in British Columbia, he sent out a release to select U.S. collectors and gallery owners publicizing the review and sold-out show, and included a postcard from the opening. As a result of the mailing, he received an invitation to show his work at a Jackson Hole gallery he had been courting for several years.

For example: You are a sculptor and your show is reviewed in *Sculpture* magazine. The local editors of the business section of your daily newspaper will be more likely to do a human interest piece on your new corporate commission if they know your work has been covered by a professional in a major art publication.

Getting art trade publicity will help the mainstream media know that you are respected in your industry. Non-art editors and collectors often don't evaluate the caliber of media you receive—they are just impressed by the fact that you got coverage. Galleries like it because it helps make their job of selling you and your work easier.

Public Relations Events

Almost any community activity you are involved in from donating works to a charity, leading an art tour to another city, designing a memorial, or acting as a celebrity chef or auctioneer is an opportunity to create positive public relations. The more you publicize these acts of goodwill, the more you will be invited to participate in other such events. Some artists literally built their name recognition from their community involvement activities.

Exhibition Openings

Celebratory parties like exhibition openings or public sculpture installa-tions are a wonderful time to connect with your community. Serious

collectors and art reviewers tend not to use openings to view the art; it simply is too crowded and not a good time for contemplation. Think of these events as prime opportunities for social networking, and choreograph them as a production. If impromptu schmoozing is not your favorite activity, consider adding a more formal element to your opening such as a slide show, interview, or walk-through talk.

Many artists exhaust themselves finishing work at the last minute, hanging the show the night before and arrive at the opening bleary-eyed and in a state of exhaustion. Consider making a cut off time of five days before the opening and stick to it so that you have plenty of time to rest and prepare for the opening. Sponsors like to keep control of these events, but some of the most successful ones are events where the artist has been involved in personalizing the presentation and where food beyond the standard cheese and crackers are offered. If the works were inspired by a trip to India, consider having Indian hors d'oeuvres or a sitar player—anything to give it a little special atmospheric and buzz as a "happening."

Make an effort to greet and thank each person who attends, and be prepared in advance to answer a few standard questions about the work. Have someone else be responsible for selling the work, giving out information, and keeping track of people who express interest and need follow-up calls. Keeping a little notebook to record notes to jog your memory the next day is a handy way to not lose track of potential leads. Always have a handful of business cards to pass out if someone asks how they can reach you. If you drink, limit yourself to one or two so you can remain alert and coherent.

ARTIST TIP: Not all sponsors use mailing list books to capture visitor contact information, primarily for expense reasons; they do not want to add people to their mailing list that they do not know. Traditional mailing list books do not ask for e-mail addresses, though this is critical information for an effective PR campaign today. You might consider making up your own form, placing it in a three ring binder, and asking people when you introduce yourself to sign the guest book. Such forms are fairly easy to create in most word processing programs.

Networking

I can't say enough about the value of networking. All artists need to find their own way to perform this fundamental career-building activity. If

you ask any well-known, successful artist how she achieved her position, she will inevitably attribute her success in some small or major part to her network of contacts. Dealers rely heavily on the advice of their gallery artists to tell them about new young talent they should be looking at. Introductions through a respected artist have always been the back door entry to a gallery. Part of any annual plan should include influential artists and other people that you want to make or rekindle contact with on a regular basis. Schedule time into your calendar just for the purpose of connecting with people on your list.

Both PR and marketing are a numbers game, and the more contacts you make either in person, by phone, mail, or e-mail, the better your chances of people knowing that you and your work exist. No matter how much talent you have, there is a direct correlation between visibility and the acceleration of your career. There are many ways to network without leaving your studio, including writing thank you notes to every one who helps you in your career, adding handwritten notes to exhibition announcements, making announcements of milestones such as grants or commissions, writing to critics or gallery owners to tell them you liked a review they did or an exhibition they presented, maintaining internal releases (see page 17), periodic newsletters, and web blogs. If you have a day job, use it to publicize your art. Volunteer to design the office holiday party invitations and donate a piece to your workspace so that all of your colleagues know that you are an artist. And don't neglect all of the potential contacts in your personal life. Everyone you meet is a potential networking opportunity.

How to Avoid Career Development Procrastination

Timing is everything in PR, and the media waits for no one. Here are some tips to help you avoid procrastination:

- Use the "toffee" technique: Bite off a little piece at a time.
- Prioritize and do the most distasteful part first. The rest will come easily.
- Mentally rehearse challenging activities that you are avoiding. For example, mentally rehearse by visualizing a successful visit to a gallery and interacting with the staff. Do it fifty times before you actually attempt it in real life.
- Use the "fifteen-minute plan": Work for fifteen minutes and then stop and reward yourself.
- Plan a reward for a particularly onerous task.

- Avoid thinking about the big picture; focus only on the immediate tasks you have committed to do. Post it in a prominent place.
- Ask a friend to coach you or get a goal-partner.
- Commit your goal or task to writing. "By January 15, I am going to contact five galleries in New York about representing me." Post it in a prominent place. Check off each task when it's done.

Use Your Life for PR

Whatever you do, wherever you go, have a PR strategy. Let's say you are going to a dinner party. Before you go, think of three goals for the activity. For example, you might resolve to get three new names for your mailing list. Or to hand out three business cards to new potential contacts. The more you incorporate networking like this into your life, the easier it will be for you.

Self-Marketing for the Reluctant

If marketing yourself is distasteful to you, some of the ideas in this chapter may strike you as crass. People who are social connectors do these things naturally, without thinking about it. They are genuinely interested in people and pride themselves in making and keeping social connections. In a sense, people are their medium.

If you embrace the perspective that people are genuinely interested in knowing you and your work, and show reciprocal interest in them, it may make this kind of reaching out and maintaining contact easier. My experience with the general public is that people love to be close to creative people and the creative process. If you are open and help demystify creativity or the creative life for others, you may find many social and artworld doors open to you.

15

BE NOT OVERWHELMED

After reading this book, you may feel that you could spend all the hours in the day dreaming up PR strategies, putting them into action, and then measuring your success. To some extent, you are only limited by your energy and enthusiasm, but I realize that running a gallery is a multifaceted task. It helps to have a clear sense of how much time you want to devote to publicity. This can range from a few hours a week to a number of days a month, depending on your resources and what you want to achieve.

By setting clear objectives and breaking them down into three-month plans of action, you can have a manageable program with quarterly feedback on how well you are doing. This seasonal planning also lets you schedule extra PR efforts, such as seeking feature articles or writing informational pieces, during periods when business slows down.

In the beginning, when everything is being done for the first time, taking on all the strategies suggested in this book would probably be overwhelming. Once you decide what kinds of publicity are most important to your gallery, concentrate on those. Then gradually expand your efforts.

The first year, you may just want to set up your basic publicity tools and send out releases to the print media. The second year, you may decide to go after electronic media as well and to seek a feature article on yourself or the gallery. The third year you might branch out into cooperative ventures. And so on. But it will always be best to concentrate on those things you can do consistently and well.

Keep in mind that it is generally difficult to measure precisely the results of publicity efforts. Unlike other strategies, such as promotional advertising, PR works slowly and indirectly. The indices of your success will be more elusive, but in time your efforts will bring monetary rewards along with increased goodwill and name recognition.

One of the most satisfying aspects of PR is that, after a short while, a well-designed publicity campaign will develop a life of its own. You will find that the publicity you plant will lead to other publicity and that your growing familiarity with media people will open up opportunities that you could not have imagined in the beginning. You will find that your PR tasks grow easier—what once seemed overwhelming will have become satisfying and fun.

Directories

American Society of Journalists and Authors Directory. American Society of Journalists and Authors, 1501 Broadway, Suite 302, New York, NY 10036
www.asja.org/memdb/search.php

Bacon's Internet Media Directory. Bacon Publishing Co., 332 South Michigan, Ave., Chicago, IL 60604

Bacon's Metro California Media Directory. Bacon Publishing Co., 332 South Michigan, Ave., Chicago, IL 60604

Bacon's New York Publicity Outlets Directory. Bacon Publishing Co., 332 South Michigan, Ave., Chicago, IL 60604

Bacon's Newspaper/Magazine Directory. Bacon Publishing Co., 332 South Michigan, Ave., Chicago, IL 60604

Bacon's Publicity Checker. Bacon Publishing Co., 332 South Michigan Ave., Chicago, IL 60604

Editor & Publisher Directory of Syndicated Services. Editor & Publisher, 770 Broadway, 2nd Floor, New York, NY 10003-9595
www.editorandpublisher.com/eandp/resources/syndicate.jsp

Editor & Publisher International Yearbook. Editor & Publisher, 770 Broadway, 2nd Floor, New York, NY 10003-9595 *www.editorandpublisher.com/eandp/resources/yearbook.jsp*

Encyclopedia of Associations. Thomson Gale, 27500 Drake Rd., Farmington Hills, MI 48331-3535

FinderBinder®. 1713 Waring Rd. #8, San Diego, CA 92120 *www.finderbinder.com*

Gale Directory of Publications and Broadcast Media. Thomson Gale, 27500 Drake Rd., Farmington Hills, MI 48331-3535 *www.gale.com*

All-In-One Media Directory. Gebbie Press, P.O. Box 1000, New Paltz, NY 12561 *www.gebbieinc.com*

SourceBook™. Milestone Press. P.O. Box 81709, San Diego, CA 81709

Standard Periodical Directory. Oxbridge Communications, Inc., 186 Fifth Ave., New York, NY 10010

Standard Rate & Data Service (SRDS). 1700 Higgins Rd., Des Plaines, IL 60018-5605

Radio Talk Show Directory. Accuracy in Media, Inc., 4455 Connecticut Ave. NW #330, Washington DC 20008 *www.aim.org/static/82_0_7_0_C*

Periodicals

Broadcasting and Cable Magazine. Reed Business Information, 360 Park Ave. South, New York, NY 10014

Columbia Journalism Review. Journalism Building, 2950 Broadway, Columbia University, New York, NY 10027 *www.cjr.org*

Editor & Publisher. 770 Broadway, 2nd Floor, New York, NY 10003-9595 *www.editorandpublisher.com*

Public Opinion Quarterly. Oxford University Press, Great Clarendon St. Oxford, OX2 6DP, UK
www.poq.oupjournals.org

PR News. Access Intelligence, 1201 Seven Locks Rd., Suite 300, Potomac, NY 20854
www.prandmarketing.com

Public Relations Quarterly. 44 W. Market St., P.O. Box 311, Rhinebeck, NY 12572-0311

Public Relations Review. Elsevier Science, 6277 Sea Harbor Dr., Orlando, FL 32887-4800

Photo Syndicates

Associated Press. 450 W. 33rd St., New York, NY 10001
www.ap.org

Globe Photos, Inc.. 275 Seventh Ave., 14th Floor, New York, NY 10001
www.globephotos.com

Newspaper Enterprise Association. 200 Madison Ave., 14th Floor, New York, NY 10016-3905
www.unitedfeatures.com/ufsapp/home.do

UPI Newspictures. 150 H St. NW, Washington DC 20005
http://about.upi.com/products/newpictures

Wide World Photos, Inc., 50 Rockefeller Plaza, New York, NY 10020
www.apwideworld.com

Professional Associations

American Association of Museums. 1575 Eye St. NW, Suite 400, Washington DC 20005
www.aam-us.org

American Association of Museums, Professional Committee on Public Relations and Marketing. 1575 Eye St. NW, Suite 400, Washington DC 20005

Public Relations Society of America (PRSA). 33 Maiden Lane, 11th Floor, New York, NY 10038-5150
www.prsa.org

International Association of Art Critics (AICA). United States section.
www.aicausa.org

Services

Bacon's Clipping Bureau. 332 South Michigan Avenue, Chicago, IL 60601
www.bacons.com
Monitors thousands of weekly and community papers: business, trade, and consumer magazines; and news stories on wire services.

eReleases. MEK Enterprises, 9403 Good Springs Drive, Perry Hall, MD 21128
www.ereleases.com
Delivers press releases to general and targeted media contacts by e-mail.

Gebbie Press. P.O. Box 1000, New Paltz, NY 12561
www.gebbieinc.com
Provides links to thousands of newspapers, magazines, and radio and television stations that are on the Internet.

PRWeb. P.O. Box 333, Ferndale, WA 98248
www.prweb.com
Posts press releases free of charge on the Internet.

Web Sites

ArtBulletins
www.artbulletins.com
Publishes announcements free of charge of upcoming art exhibitions to 65,000 readers each day online. Internet galleries, Web sites, or Web-based exhibitions are not eligible.

Artist Help Network
www.artisthelpnetwork.com
Founded by Caroll Michels, this site is devoted to all aspects of career development, including contact information for organizations, periodicals, publications, software, audiovisual aids, Web sites, and service providers.

Mahler's Practical Guide to Promoting Your Web Site
www.1x.com/promote
Provides tips and advice on promoting Web sites, including the most important places to be listed.

MediaFinder
www.mediafinder.com
The Web site of Oxbridge Publications. You can search for and link to market trade publications, newsletters, magazines, and directories.

NewsDirectory
www.newsdirectory.com
Provides links to more than 6,500 English language print and broadcast media from around the world.

Pressbox
www.pressbox.co.uk
Posts press releases free of charge on the Internet.

Web Site Design Publications

Learning Web Design: A Beginner's Guide to HTML, Graphics, and Beyond by Jennifer Niederst and Richard Koman. Cambridge, MA: O'Reilly & Associates, 2001
www.ora.com.

The Photographer's Internet Handbook by Joe Farace. New York: Allworth Press, 1997
www.allworth.com

Re-Engineering the Photo Studio: Bringing Your Studio into the Digital Age by Joe Farace. New York: Allworth Press, 1998
www.allworth.com.

Selling Art on the Internet by Marques Vickers. Marques Vickers, Vallejo, CA: 2000
www.marquesv.com.

Publications

Fine Artist's Guide to Marketing and Self-Promotion, Revised edition, by Julius Vitali. New York: Allworth Press, 2003
www.allworth.com

Getting the Word Out: An Artist's Guide to Self Promotion, edited by Carolyn Blakeslee. Art Calendar Publishing, Inc., P.O. Box 2675, Salisbury, MD 21802

How to Photograph Paintings by Nat Bukar. Art Direction Books, 456 Glenbrook Rd., Glenbrook, CT 06406, 1996.

How to Photograph Your Artwork by Kim Brown. Canyonwinds, 28 North Rim Rd., Ransom Canyon, TX 79366

The Internet Publicity Guide: How to Maximize Your Marketing and Promotion in Cyberspace by V.A. Shiva. New York: Allworth Press, 1997

Publicity on the Internet: Creating Successful Publicity Campaigns on the Internet and the Commercial Online Services by Steve O'Keele. New York: John Wiley & Sons, 1996

Six Steps to Free Publicity and Dozens of Other Ways to Win Media Attention for Your Business by Marcia Yudkin. New York: Penguin Books USA, 1994

Although titles vary, those listed below are common.

Newspapers

- **Publishers** are the owners, or the owners' representatives, who set and supervise policies.
- **Managing editors** determine and implement such overall news coverage policies as how much of a reporter's time and how much column space should be devoted to a subject.
- **News editors** supervise reporters, editors, and writers, determining the emphasis that a particular story should receive and when it should be used.
- **City editors** serve as filters for most releases received from public relations people and supervise local reporters.
- **Editorial page editors** express the opinions of the newspaper through editorial columns. They also select editorial page materials and therefore can support or attack an institution or a point of view. Sometimes they edit the "op-ed" sections, where opinions not written by the newspaper's staff are published.
- **Sunday editors** coordinate and supervise the production of this large edition.

- **Special editors** concentrate on one or two subjects, such as travel, entertainment, food, business, education, or society.
- **Columnists** are the "personalities" of the newspaper. They usually have a following among their readers who enjoy reading what these writers say. Columns are bylined and thematic and may use ideas from public relations people.
- **Wire editors** select from the offerings of the wire services to which their newspaper subscribes those stories that are to be considered for publication. The Associated Press and United Press International are the two principal wire services. Both serve newspapers and broadcast media. Each employs "stringers," who report from outlying suburbs and rural areas and are paid for each story they submit. The wire services operate through regional and city bureaus from headquarters in New York and have "A" wires, which carry the bulk of the news, and "B" wires, which carry overload and regional news and features. In some cities, public relations staff may transmit a publicity story over the independent PR Newswire. Check with your local newspaper wire editor for information on the closest PR Newswire office.
- **Reporters** gather facts either working on their own or on assignment for an editor. Their copy is usually channeled to their editor through a rewrite person. A reporter may or may not have certain subject specialties.

Broadcast Media

- **Station managers** represent owners, set policies, and provide overall supervision.
- **Program managers** supervise the selection and scheduling of material to be aired, which may or may not include news. If there is no public service director, the program manager may determine the extent to which the station will use public service announcements (PSAs).
- **News directors** supervise camera crews, reporters, and all others associated with producing news shows. Ideas for stories that do not have to be covered that day are usually called in or mailed to the news director. Because many small radio stations do not have a news department, news is often prepared by commentators or other available personnel.

- **Assignment editors**, who usually report to news directors, dispatch reporters to cover stories. Consequently they determine in large part what will be covered locally by that day's news programs and are a key contact for the public relations person who wants a crew to visit the museum to cover a story that day.
- **Public service directors** determine what public service material the station will produce and which of the public service announcements received from the public relations people will be used.
- **Producers** originate and implement show ideas by being in charge of content, talent, and technical production. They also write material, appear on camera, and are important contacts for placing guests on shows.
- **Show hosts** select guests and material directly or through their producer and are on the air in any of several types of programs, such as talk shows.
- **Announcers**, together with show hosts, are on air or on-camera personalities. They may or may not write their own material. Contact with them is usually made through their producers.
- **Reporters** are often on general assignment and are not briefed on the stories they are covering. They will be too busy to spend time on a story unless it is scheduled for that day's news. Some reporters specialize in certain subjects, such as consumer affairs or lifestyles, and have a hand in choosing their own material. They usually report to the news director. One may contact specialized reporters directly with appropriate story ideas.

This media personnel listing is reprinted by permission of the publisher, from Donald Adams, *Museum Public Relations,* AASLH Management Series, vol. 2 (Nashville: American Association for State and Local History).

ABOUT THE AUTHOR

SUSAN ABBOTT has been a fine art marketing consultant and creator of training programs for art professionals for more than two decades. Her firm, Abbott & Company, Inc., offers personalized consulting on fine art public relations and career development to galleries, museums, and artists. She is a well-known speaker on fine art marketing, and the enthusiastic response to her annual seminars in the United States, Britain, and Japan led her to develop this book. She has also been a featured speaker for the National Endowment for the Arts and the American Association of Art Museums. As founding director of Art Programs, Inc., and Abbott & Company, Inc., she has provided art acquisition, exhibition, and public relations services for Fortune 500 corporations, including Chevron, U.S.A., Genentech, Inc., Transamerica, and Macy's. She is the author of *Corporate Art Consulting* (Allworth Press), as well as a former contributing editor of *Art Business News* and a director of Art World Press.

Susan Abbott can be reached at:

Abbott & Company, Inc.
841 Smith Road, Mill Valley, California 94941
Phone: 415-383-3242
E-mail: *sa@abbottandcompany.com*

press kits for, 135–136
press releases for, 123–139 (*see also* press releases)
publicity campaigns, scheduling for, 118
schedules for, 60, 72
timing for, 117

fact sheets, 131
file organization for publicity, 40–44
FileMaker Pro software, 37, 75
forms. *see* worksheets
Freeman Gallery, 29
Fugate-Wilcox, Terry, 29–30

Gale Directory of Publications and Broadcast Media, 35
Gallerie Maeght, 10
galleries
 African Arts Gallery, 100–101
 art critics perception of, 54–56
 Borofsky gallery, 79
 Bradon Gallery, 133
 building name recognition, 4
 Castelli Gallery, 10
 Charles Cowles Gallery, 79
 cooperative ventures with, 26–27
 description of, 10–11
 Donald Judstone Gallery, 95
 Freeman Gallery, 29
 Gallerie Maeght, 10
 Gallery Riche, 132
 image development for directors, 20–21
 Makk Gallery, 28
 Marco Sassone gallery, 78
 schedules for exhibits, 60
 staff attitude at, 56
 Tompkins Gallery, 98
 Tuller-Stack Gallery, 118
 virtual tours of, 71
 William Hill Gallery, 129
gallery directors, xiv
Gallery Riche, 132
Gardner, Paul, 5, 29
Gebbie Press Media Guide, 84
Glueck, Grace, 45
Google search engine, 85, 86

Hernandez, Larry, 129
Hess, Elizabeth, 56, 124

high-resolution images, 76
How to Survive and Prosper as an Artist (Michaels), 144

image development, 12–13
 gallery directors, 20–21
information, background, 99–101
International Council of Museums, 45, 47, 97
Internet, 83–92. *see also* Web sites; World Wide Web
interviews, 50–51, 66–67
 press releases including, 123–124
inverted pyramid format, 106–107, 128
Itinerant Artist, 82

Karp, Ivan, 20
Kelly, Kate, 103
keywords (metatags), 85
Krent, Thomas, 95
Kukurin Company, 28

letterhead, 113
library of samples of publications, 44
Liener, Michael, 23
Life Lessons (film), 55
listserves, 87
Looksmart/Zeal, 85
Los Angeles Times, 54, 55, 143
low-resolution images, 76

mailing lists, 52
Makk Gallery, 28
Marco Sassone gallery, 78
Marketing Artist software, 75
marketing plans, 9–18
 communication of, 17
 gallery description, 10–11
 goals and strategies, 12–14
 for individual artists, 144–146
 measuring success of, 17–18
 niche and Web sites, 73
 target audiences, 39
mass culture, xi
media coverage, xi–xii, 33–44
 artists judged by, 5
 artists keeping copies of, 152–153
 categories of, 36
 filing organization for, 40–44

Village Voice, 56, 124
virtual tours, 71
Visions (magazine), 55

Warhol, Andy, 30
Web bulletin boards, 87
Web rings, 86
Web sites, 69–82, 152
 content development, 13
 digital images, 75–78
 discussion groups, 87
 educational material on, 73–74
 equipment and software for, 74–75
 justification for, 70–72
 linking to, 81
 linking to other sites, 86–87
 online media directories, 34–35
 photographing art, 77–78
 press kits, including address with, 47
 pressrooms on, 72–73
 samples of, 78–79
 selling from, 74
 updating, 80–81
William Hill Gallery, 129
worksheets
 artist description, 16
 background releases, 104
 exhibition invitations, 138–139
 exhibition press release, 126–127
 gallery description, 11
 media list entry, 38
 planning form for exhibition publicity, 122
World Wide Web, 83–92
 communication on, 88–91
 networking on, 87–88
 as a research tool, 83–85
 search engines, 85–87
writers, working with, 48–50, 52–54
writing
 articles for publication, 21–25
 posting articles on Web site, 73–74
 press releases, 103–111 (*see also* press releases)

Yahoo!, 85

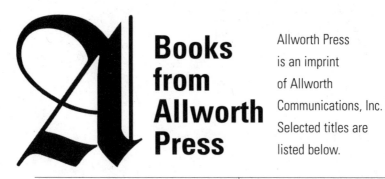

Books from Allworth Press

Allworth Press is an imprint of Allworth Communications, Inc. Selected titles are listed below.

THE FINE ARTIST'S GUIDE TO MARKETING AND SELF-PROMOTION, REVISED EDITION
by Julius Vitali (paperback, 6 × 9, 256 pages, $19.95)

THE FINE ARTIST'S CAREER GUIDE, SECOND EDITION
by Daniel Grant (paperback, 6 × 9, 320 pages, $19.95)

THE BUSINESS OF BEING AN ARTIST, THIRD EDITION
by Daniel Grant (paperback, 6 × 9, 354 pages, $19.95)

BUSINESS AND LEGAL FORMS FOR FINE ARTISTS, REVISED EDITION
by Tad Crawford (paperback, includes CD-ROM, 8½ × 11, 144 pages, $19.95)

LEGAL GUIDE FOR THE VISUAL ARTIST, FOURTH EDITION
by Tad Crawford (paperback, 8½ × 11, 272 pages, $19.95)

THE ARTIST-GALLERY PARTNERSHIP: A PRACTICAL GUIDE TO CONSIGNING ART, REVISED EDITION
by Tad Crawford and Susan Mellon (paperback, 6 × 9, 216 pages, $16.95)

AN ARTIST'S GUIDE: MAKING IT IN NEW YORK CITY
by Daniel Grant (paperback, 6 × 9, 224 pages, $18.95)

THE ARTIST'S QUEST FOR INSPIRATION, SECOND EDITION
by Peggy Hadden (paperback, 6 × 9, 288 pages, $19.95)

THE QUOTABLE ARTIST
by Peggy Hadden (hardcover, 7½ × 7½, 224 pages, $19.95)

HOW TO GROW AS AN ARTIST
by Daniel Grant (paperback, 6 × 9, 240 pages, $19.95)

THE ARTIST'S COMPLETE HEALTH AND SAFETY GUIDE, THIRD EDITION
by Monona Rossol (paperback, 6 × 9, 416 pages, $24.95)

Please write to request our free catalog. To order by credit card, call 1-800-491-2808.

To see our complete catalog on the World Wide Web, or to order online, you can find us at
www.allworth.com.